TAKING PICTURES
FOR PROFIT

TAKING PICTURES
FOR PROFIT

LEE FROST

David & Charles

To my mother, whose short life was an inspiration.

A DAVID & CHARLES BOOK

First published in the UK in 1996

All photographs by the author except for the
following:

Geoff Du Feu, pages 12,13; David Tarn, pages 64, 65;
Mike Pett, pages 66, 67, 70, 71; Derek Gadd, page
68, (both); Graham Peacock, pages 82, 83 (both);
Mike Busselle, pages 93, 95; Nigel Harper, pages 11,
46, 97, 102, 103 (both); Colin Leftley, pages 104,
105, 110, 111; Ed Buziak, pages 106, 108; Alan Blair,
pages 118, 119 (both); John Potter, pages 128, 129
(both); Steve Marley, pages 136, 137; Duncan
McEwan, pages 148, 149 (both); Images Colour
Library, page 151.

A catalogue record for this book is available from the
British Library.

ISBN 0 7153 0312 0

Book design by
Casebourne Rose Design Associates
and printed in the UK by BPC Paulton Books Ltd
for David & Charles
Brunel House Newton Abbot Devon

CONTENTS

INTRODUCTION

I decided I wanted to be a freelance photographer when I was 15 years old. I didn't really know what that involved, and I barely knew one end of a camera from the other, but hey, I had a Zenith, I read National Geographic, and it seemed like an exciting way to spend my life – certainly better than working down the mines, which is where many of the children in my home town ended up.

At the time no one took me seriously. My careers officer at school tried to talk me into a more sensible occupation, suggesting that photography wasn't a 'proper' job. My friends laughed at the whole idea, telling me that working-class kids just don't do glamourous jobs like that – they work in shops, or learn how to mend cars. As for my parents, they supported me all the way, perhaps thinking that if they kept quiet I'd wise-up. I didn't.

More than a decade down the road, I've achieved that goal. I no longer have my trusty Zenith – it was upgraded years ago – but I still read National Geographic, and I can say, hand on heart, that being a freelance photographer is an exciting way to spend your life. It's a hard slog, it's unpredictable, and at times it can be downright soul destroying. But so far I have little to complain about. I live in a nice house, I drive a nice car and I get to travel the world – all paid for by photography, something I still consider to be a hobby and something I'd happily do for free. What could be better than that?

When I started out I learnt by trial and error. It took years of practice and dedication to fine-tune my skills as a photographer – I've still got a long way to go in that department. Then once I felt confident of my work, it took several more years of hard work before I began to make regular sales.

Taking Pictures for Profit has been written to make your first steps towards a career in freelance photography much easier that mine were. Page-by-page it will take you through the many factors that have to be considered, from the type of photography you would like to specialise in, to promoting yourself and establishing a smooth-running business.

There's also a large section dedicated to the many different markets available to freelance photographers, with advice on what they need and how you can make regular sales. This is backed-up by interviews with photographers specialising in those markets, and where relevant, the people involved in buying or commissioning photography, so you get both sides of the story from those who really know.

All in all, this makes *Taking Pictures for Profit* the definitive guide to freelance photography. I can't guarantee it will make you a better photographer, but I can promise that by the end of it you'll have a much clearer idea of what being a freelance photographer is all about, and how you turn your hobby into a profitable business.

Good luck.

Lee Frost

BUSINESS SENSE

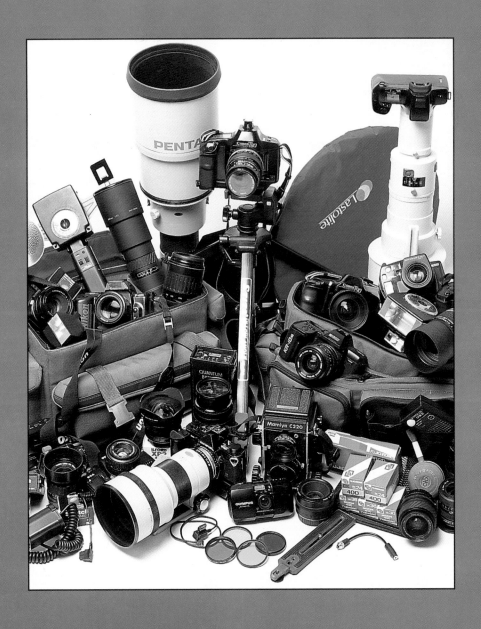

THE ROAD TO FREELANCING

At some point in their career as amateurs, most photographers dream of one day picking up a camera and using it to make money instead of merely practising a hobby. This is a completely natural reaction. If you enjoy something and you're good at it, it's human nature to want to do it even more, and if you can earn a living at the same time, or at least cover your costs, then so much the better.

I faced a similar dilemma over a decade ago. After *Camera Weekly* magazine published a set of my pictures, I suddenly decided I was ready to launch my talents as a photographer on the world, and spent hours dreaming of all the exotic locations I would be able to visit and all the money I would earn. Of course, at the time, I knew nothing of what it involved or where I'd start.

A few years later, I applied to a government-funded scheme which helped unemployed people set up in business. For a year I was paid a nominal amount each week to prove just how little I knew about the profession of photography, and by the end of it all I'd sold three pictures to a photographic magazine and a colour print to the manager of a hotel featured in one of the night shots that were published two years earlier!

Despite these initial set-backs, however, my enthusiasm remained intact. In fact, my initial failure made me more determined than ever to succeed, and ten years on I at last feel as though I'm getting somewhere. I also learned a lot along the way, and it's for this reason that I decided to write this book. Hopefully, by sharing my experiences, you can learn from my mistakes, and your path to a successful freelance career will be far less painful, not nearly so frustrating,

and one day you will experience the same excitement, satisfaction and freedom that I feel every time I pick up a camera.

But before examining the specifics of freelancing, let's first look at the many options open to you.

Firstly, what exactly is a freelance photographer?

That's easy: it's someone who works for himself (or herself) and offers their services as a photographer to the general public, industry, commerce and anyone else who needs a photographer from time to time.

Within this broad spectrum, you'll find photographers who specialize in one area, such as weddings and portraiture, fashion and beauty, news, sport or travel. There are also many 'commercial and industrial' photographers who do a bit of everything, while others concentrate on illustrating books, magazines, calendars and postcards with their pictures. Then there are the lucky few who handle big projects for the top advertising agencies, or who spend their time travelling the world shooting 'stock' images for international picture libraries.

My field has always been travel and landscape work, simply because I love wandering around looking at the world. But I also know photographers who cover all sorts of other things, from illustrating gardening features in magazines to documenting world events for international news agencies.

The chances are that one of the areas mentioned above will appeal to you. If not, you'll

Travelling around the world photographing famous places has to be one of the most desirable areas of professional photography. This also makes it one of the most competitive areas though, so you need to be good to succeed.

probably be happy to photograph anything. This may sound rather erratic, but it's a great way to start because it gives you a lot of invaluable, practical experience at tackling different commissions and dealing with different people.

Throughout this book you'll find profiles of photographers operating in all of the areas mentioned above who I've managed to cajole into revealing the secrets of their chosen subject. By reading about what each area involves, you can decide whether or not you want to pursue a career in that field.

What kind of person do you need to be to succeed as a freelance photographer?

That's not quite so easy, mainly because it depends upon the area of photography you decide to pursue. However, one common factor that links them all is that freelance photography involves being self-employed. That means as well as being a great photographer you also need to be a good businessman (or woman). You need to be confident of your abilities, willing to work long, hard and often unsociable hours, able to

If you enjoy the thrill of documenting human life, then press or reportage photography could be an exciting path to follow.

to help cover the cost of film and processing so there are no real risks involved.

If, on the other hand, the idea of taking risks, and not always knowing what you'll be doing from one week to the next, seems appealing, you may have what it takes.

Don't make your mind up just yet, however, because you'll find chapters throughout this book to help you with the business aspect of freelancing – such as accounting, planning, investing in equipment, self-promotion, selling your wares and everything else you need to turn your hobby into a successful venture.

Should you pursue your freelance career on a part-time or full-time basis?

The answer to that is the same as the last – it depends. When I started taking photography seriously as a career, I was fresh out of college with no real commitments or responsibilities. Nor had I grown accustomed to a regular income and all the trappings that brings, so if I went a week without earning any money, I went hungry.

Unfortunately, that's not an attitude you can adopt if you have a family and large financial commitments. Also, if you are accustomed to a regular income and certain standard of living, the strain of risking that to chase a dream can be immense.

Some people have turned their backs on careers literally overnight and established successful businesses without too much pain, but it is a massive risk to take if you don't have some kind of financial support from a spouse, or savings that will see you through until you earn a proper income from photography.

If you don't, then it's wise to take things slowly and begin by freelancing in your spare time while still retaining your existing job, if only for the financial security it guarantees.

This inevitably imposes limitations, because there's only so much you can do during the

promote your services effectively, deal with a variety of people, keep accounts and records, manage your finances and plan ahead so your business grows.

It's a sad fact of life that you can be one of the greatest photographers on earth and yet fail miserably because you are unable to sell yourself. At the same time, there are many photographers operating today with little photographic talent but a good head for business.

If the very thought of this makes you break out into a cold sweat, you have two options: either forget the whole thing and keep photography purely as a hobby, or just freelance as a sideline

evenings and weekends. However, later on in this book you'll see that there are many areas of photography that can be successfully tackled by part-time freelancers. Also, by taking this route you can gradually build up a client base and get to know what the profession is all about, without being under pressure to succeed from the outset.

My advice is keep your full-time job until at least half your income comes from photography. Once you reach that stage you can feel pretty confident that your talents are in demand, and that given more time you could get more business. Most of the photographers featured later took this route.

What are the chances of me succeeding as a freelance photographer?

That depends how badly you want to succeed and how much effort you're willing to put into developing your freelance business. If you're happy to cover a wedding every week or two, sell the occasional picture to a magazine or shoot stock, then you shouldn't have any problems achieving your goal. However, if you want to turn a steady sideline into a successful, profitable career, then it's going to take time, hard work and dedication.

Professional photography is a fiercely competitive field where only the most committed make good, so if you're only looking for glamour and prestige, look elsewhere. For every successful freelance photographer who makes a very comfortable living, there are many struggling to make ends meet doing boring jobs. Also, most of those photographers who have succeeded have done so only after years of hard work, so surely they deserve to be rewarded for their effort.

The most important thing to remember is that taking pictures for love in your spare time is a far cry from taking pictures to feed and clothe your family. You can't always photograph what you want to, you'll often have to work long hours,

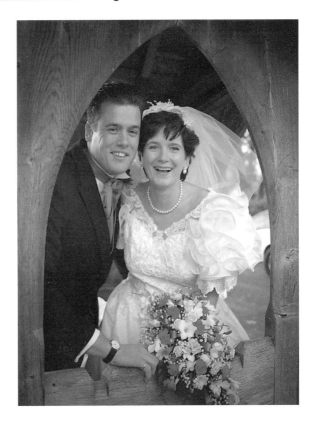

Wedding photography is one of the most popular and accessible subjects for part-time freelancers as it is something you can do at weekends while still continuing your main occupation.

and you don't always get thanked for it. Also, like any job, there will be times when the very thought of picking up a camera makes you want to scream. It happens to us all. It has certainly happened to me in the past.

So why is it that so many people turn their backs on stable careers in pursuit of a dream? Because of all the ways there are to earn a living, photography has to be one of the most exciting, challenging, rewarding and fun. After all, how many people do you know whose hobby is also their job?

Name: **GEOFF DU FEU**

Geoff du Feu is living proof that a photographic hobby can be turned into a profitable business – if not without its problems. Three years ago both he and his wife were simultaneously made redundant from their jobs, and he found himself with a choice to make: apply for unemployment benefit, or try to make a living from photography. No prizes for guessing which option he chose.

'Losing my job was a big shock. My wife and I had moved to the country with our work, so when that went we found ourselves out in the sticks with children and a mortgage and no real prospects. We received very little in the way of financial remuneration, but fortunately we had a little money saved, so I decided to use that to help get the business up and running. I'd already been quite active as a part-time freelancer for a few years, submitting stock to picture libraries and selling pictures to photographic magazines. But it was on a relatively small scale, and I knew that to make a living from it I'd have to be much more prolific.

'Around the same time, I met a photographer who had found himself in a similar situation a few years earlier and started shooting stock. He was lucky because he could afford to invest quite a lot of money in building up his stock, but his attitude was, "I did it, so can you". So I decided to try.

'In the beginning, it was quite tough. I didn't have the money to pay for exotic foreign stock shoots so I had to concentrate on things closer to home. Natural history is my main passion. I also started photographing my children, and if I found myself in a large city, I'd make the most of it by taking my camera gear along.

'The first year was spent building up enough stock so I could approach new picture libraries. I was keen to become established with a German library, for example, but they wanted to see 700 medium-format pictures as an initial

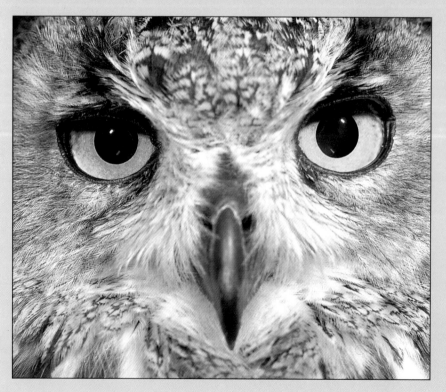

Nature and natural history feature heavily in Geoff's work. This close-up of an eagle owl, taken at a local falconry centre, is another regular seller, and illustrates the diversity of skills that have earned him success as a stock photographer.

submission. That took a lot of time and money to achieve. I also decided that I'd supply a variety of different libraries with specific subjects. All my natural history pictures go to one, all my pictures of children go to another, and so on.

'The second year was then spent building up the stock with each library and giving it a chance to sell. It's only now, in the third year, that I'm starting to see regular returns. I have about 10,000 pictures with the libraries in total, and I supply 10 different libraries around the world.

'When I started out, I told myself I'd give it three years then see how things were going. The last few months have been very good, and I'm beginning to feel rather optimistic about the future. I still don't make a proper living from my photography – the returns are less than my salary used to be – but I'm now at the stage where I can draw a small amount of wages from the business to supplement the money my wife earns with her part-time job, and I'm able to cover all my costs.

'Shooting stock is expensive, and very unpredictable. It's difficult for me to make specific plans, because I never know how much money I'll make from one month to the next. Saying that, I do enjoy the freedom it provides. Some days I get up and have to force myself to get out with a camera – I'll clean the house and do all sorts of things to provide an excuse for putting off work – but overall I much prefer it to a regular day job.

'I always disliked working for someone else and I've always been a frustrated freelance photographer, so now I suppose I'm doing what I've always wanted to do. It would just be nice if I could earn a little more money, although I'm sure that will happen one day soon.'

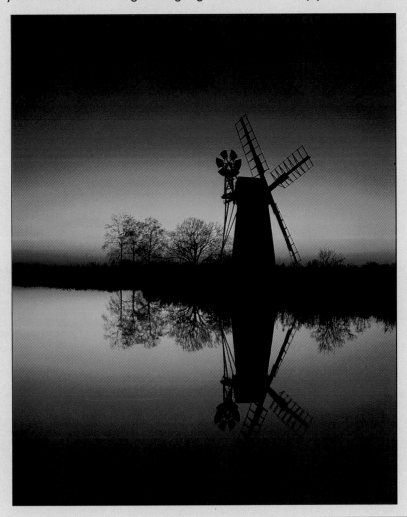

Geoff du Feu regularly photographs the regions around his home, and the pictures sell well through the libraries he supplies. This beautiful sunset showing an old mill has been particularly successful for him.

SELLING YOURSELF

SELF-PROMOTION and presenting a professional image is an important aspect of freelancing: the former to let people know you exist in the first place, the latter to show them you're efficient and credible when they get in touch.

Over the years, I've seen many different approaches to both tasks, some original and creative, others cheap and amateurish, and many in between that did the job quietly and without fuss. Obviously, at the end of the day it's the quality of your photography that counts, but the way you promote and present it is very important as it immediately gives potential clients an impression of you. Also remember that in many cases, people will be seeing your work before they see you, so you need to impress and reassure them from the start. There are various ways to achieve this.

Personalized stationery

First of all, you will need some business stationery which you can use when sending out pictures, estimates, proposals and so on. As a minimum this should comprise headed writing paper, compliment slips and business cards.

If you're unsure where to begin, call in to a high street printshop and talk to someone. Most outlets offer a comprehensive service, with prices to suit all budgets, and often they offer special discounts for new businesses, or package deals for the standard items. You will be shown different design options in terms of typography, colour, layout and paper type – the ones you choose are up to you.

Initially, keep things simple, otherwise you could find yourself spending a lot of money. A two-colour layout (black plus another colour) looks effective and doesn't cost too much, and batches of 500 letterheads, slips and cards will keep you going for a while. I asked a designer friend to create a logo, choose the type faces and produce artwork ready for printing, but most printshops will offer this as part of a package.

The main problem with personalized stationery when you first set up in business is knowing what information to include. Your own name, with a line beneath it saying 'Freelance Photographer' or whatever title you prefer, is perfectly satisfactory. Your address and telephone number are also essentials, along with fax and mobile phone numbers if you have them. Once you become established, you might find certain legal obligations affect your stationery. For example, if you register for VAT (value added tax) in the UK, your registration number must appear on your letterheads.

Photocards and leaflets

Along with business stationery, many freelance photographers also have a photocard printed which features one or more examples of their work, along with their name, telephone number and maybe a contact address. This is a very polished and effective way of promoting yourself, as many users of photography often pin attractive cards to notice boards, so they have a constant reminder of your work. Standard business cards, on the other hand, tend to be slipped into a special album if you're lucky, more often dropped into a drawer, or lost forever if you're unlucky.

Costwise a colour photocard is well within reach of the smallest budgets, and if you shop around you shouldn't have any problems finding a printer who can produce one for you. Usually a standard layout is offered – say, one image plus up to 50 words of text on the back. However, this can be varied to suit your needs for extra cost. For example, you could have four or five different

Colour or black and white photocards showing examples of your best work are an inexpensive but highly impressive form of self-promotion – copies can be sent out with every picture submission so clients have a ready reminder of you and your work.

Tearsheets showing examples of published work look very effective when mounted on black or white card then laminated between sheets of clear plastic film.

images on the front along with your name and phone number, plus a couple of black and white pictures on the back with a brief description of the type of work you undertake.

These cards are ideal for mailing out with picture submissions, or as a promotional tool if you decide to mount a campaign of contacting local companies, book publishers or magazines – just send them out with a brief covering letter.

Another option is to have a colour sheet printed on glossy paper featuring a selection of your best images plus lists of subjects you cover or subjects you have on file. This is a great way to impress magazine editors, art editors and other people

who commission photographers or buy pictures, as it looks very professional. Again, you can have these leaflets produced by most high street printers, and the price isn't at all excessive – one job obtained this way can pay for the complete print run of 500 or 1,000.

Advertising your services

If you intend working as a social, industrial or advertising photographer then work is going to come from members of the public or businesses. As a result, they need to know you exist, and that means advertising your work.

One of the most effective ways is to advertise in the business services telephone directory for your area. This is quite costly as you pay for a full year, but it's where most people look when they need to use a photographer, and I personally know of several professionals who are convinced it is an excellent means of getting work.

Paying for a few lines of type in the photographers' section of the directory is the cheapest option, but it might prove better to invest more in a small box, as it will stand out and suggest you have a successful business even if you've just started out.

On the social side there are also other ways to promote yourself. You could advertise in local newspapers when they run a professional services section, or in any issues that contain wedding promotions. Local bridal shops may also be willing to pass on business cards to customers and perhaps display some of your work in the window, while bridal shows are always a good place to find work as they are attended by brides-to-be who are often looking for the very services you offer.

Another way of making local people aware of your work is by organising an exhibition. This could be in a cafe, club, library, town hall, civic centre, or a variety of other venues (see pages 120–129 for details on how to mount an exhibition).

In the beginning, the more you promote your name, the better, but as your business begins to grow you'll probably find that an occasional advertisement in the local newspaper and an appearance in the business telephone directory is all you need to keep a steady flow of new clients coming in.

A carefully produced portfolio is by far the best way of showing off your talents to prospective clients such as magazine editors, art directors and local businesses. Here, a combination of mounted prints, tearsheets and colour slides constitute an effective means of promotion.

Creating a portfolio

In some areas of photography – commercial and industrial, advertising, wedding and portraits, and magazine and books – it's also important that you have a good quality portfolio of your best work ready to show people. If a new client calls, for example, and asks to see some pictures, the last thing you want to do is start scrambling around trying to put together a set. Equally, no magazine editor is going to be impressed if you turn up for an appointment with an envelope full of dog-eared prints and dusty slides. So, if you intend pursuing any of the areas mentioned above, you need to create an impressive portfolio from the start.

Ideally, this should comprise a mixture of prints, colour slides and tearsheets showing examples of published work where relevant. Prints should be at least 12x16in (30x40cm), and presented in such a way that they can be handled regularly without being damaged. I personally prefer to window-mount prints behind 16x20in (40x50cm) sheets of white card and slip them

Prints are best presented in carefully cut window mounts which can be stored in clear polythene sleeves.

into clear polyester sleeves which can be replaced periodically (see pages 122–3 for details on how to window-mount). Other photographers prefer to dry-mount the print on thinner card then have the whole thing encapsulated or laminated between two sheets of clear plastic, so the print is fully protected, and any fingermarks can be wiped off.

The best way to present colour transparencies is in black card masks. A variety of different types are available, but the most flexible are standard size sheets of stiff black card with apertures cut in to accept individual black mounts. These are ideal because you can mix upright and horizontal shots on the same sheet, whereas the standard multi-image masks limit you to one or the other.

Tearsheets from books, magazines, brochures and so on can be mounted on card then encapsulated like prints. However, I prefer to use a good quality hardbacked 'pro-book' which has

a leather cover and contains 20 or more clear plastic pockets with sheets of black card in. The books I use are an ideal size to hold magazine tearsheets, and provide a neat black border around the page.

Once you've put together a portfolio, it obviously needs to be stored in something. Successful professional photographers often spend a lot of money having bespoke cases made from wood, leather and all sorts of exotic materials. However, you needn't be so extravagant to make a lasting impression.

The most popular form of case is the design with a zip on three sides and a ring-binder mechanism on the spine on to which you can

An alternative way to present a portfolio comprising entirely of prints is in a solander-style box.

clip clear pockets containing your prints, slides and tearsheets. They come in all sizes, are economical and look good. However, they are also a little impractical as you either have to lay the whole thing out on a table or remove the contents.

For this reason, I prefer briefcase style cases with a hinged lid and open interior as they're more flexible if you need to combine items of different size. Large artists' supply shops usually stock them, and manufacturers often advertise in the classified sections of art design and professional photographic magazines.

Overall, the key to creating a stylish portfolio is keeping it simple, consistent and up to date. Don't put lots of pictures in unless you have a specific reason – 20-30 pictures is more than enough – and make sure you update it regularly with new work, or remove items that are beginning to look worn. It's also a good idea to tailor the contents to suit the person you're seeing, rather than showing the same pictures to everyone – a portrait client will not necessarily be interested in seeing landscapes, and equally, the editor of a gardening magazine won't be interested in creative studio portraits.

CHOOSING EQUIPMENT

NO MATTER WHICH AREA of photography you decide to pursue, you can't do it successfully without the right equipment. Many budding freelancers use this as a cue to rush out and spend a fortune on mountains of equipment. Others feel inadequate because they can't afford to invest in the latest hi-tech hardware, and have to settle for the same antiquated system they've been using for years.

Both reactions are unwise and unnecessary. If you have legitimate reasons for investing in a piece of new gear, fine, but if it's just to satisfy your love of hardware, forget it, otherwise you could find yourself burdened with unhealthy debts, equipment you will never use, and all your capital eaten up before you start. The worst way to start a business is in debt, so take heed.

What you must do is treat your freelance

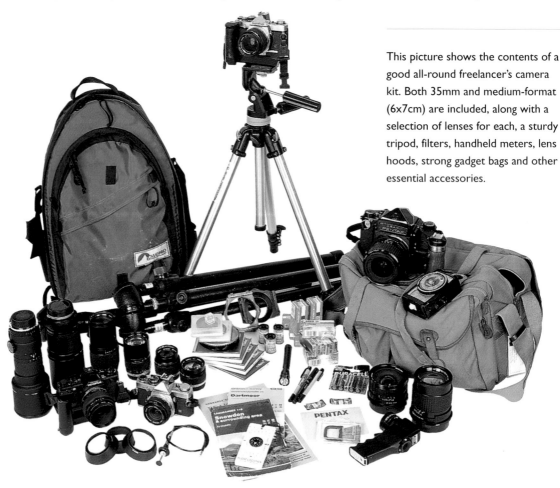

This picture shows the contents of a good all-round freelancer's camera kit. Both 35mm and medium-format (6x7cm) are included, along with a selection of lenses for each, a sturdy tripod, filters, handheld meters, lens hoods, strong gadget bags and other essential accessories.

activities purely as business. You may enjoy them immensely, but at the end of the day you're still in business to make a profit, so it would be silly to buy equipment for the sake of it. Other business people don't. After all, when did you last come across an electrician or a plumber with a van full of redundant tools?

Being able to buy and use the latest and best equipment is one of the advantages of establishing a successful business, but you don't actually need it to take saleable shots, so avoid the temptation and before making any rash decisions, take a long, hard look at what you already own.

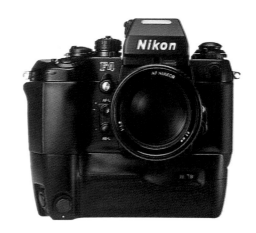

Cameras and lenses

Deciding what type of equipment you really do need will depend mainly on the area of photography you intend covering.

The probability is that most enthusiastic photographers already own a 35mm outfit with a selection of lenses, a tripod, flashgun, filters and all the usual paraphernalia that's associated with amateur photography.

If you intend shooting stock for a picture library, submitting work to magazines and books or postcard publishers, or trying to sell work to newspapers, then the 35mm format is perfectly acceptable. I started out with a basic manual focus 35mm system, and used it for at least the first five years of my part-time freelance career. In fact, I still use most of it today, along with other bits and pieces that have been added.

A good all-round 35mm kit would comprise 2 SLR bodies, ideally with motorwinders, lenses from 28–200mm (this can be covered by, say, 28mm, 35mm, 50mm, 85/105mm and 200mm lenses, or a couple of good quality zoom lenses such as a 28–80mm and 70–210mm). The camera maker's own lenses usually have a slight edge over independent models in terms of sharpness, but the latest models from manufacturers such as Sigma and Tamron are excellent, and I know many photographers who use them professionally.

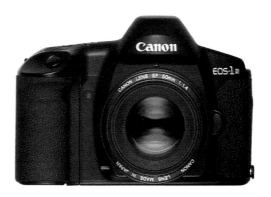

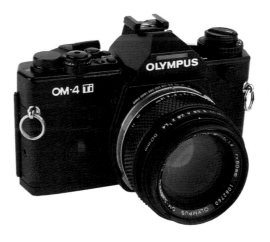

Professional SLR cameras such as the Nikon F4, Canon EOS-1N and Olympus OM4-Ti are popular choices among freelance photographers for their robust design and reliability.

There are many options facing the photographer investing in a medium-format camera system – not least the various format sizes available.

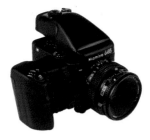

The Mamiya 645 Pro (6x4.5cm) is a favourite among location photographers for its superb handling – it's as easy to use as a 35mm SLR but gives much bigger images.

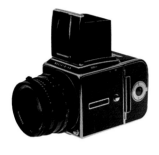

Models such as the 6x6cm Hasselblad 503CX tend to be used mainly by portrait and wedding photographers, but the square format can be limiting for general use, as most published pictures are cropped to rectangles.

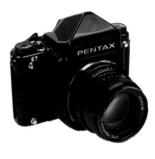

The more compact Pentax 67 comes into its own when your working day involves a lot of walking around, so it's used by many freelance landscape and travel photographers.

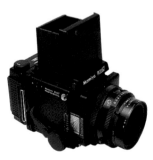

The unfailing Mamiya RZ67 (6x7cm) is probably the most popular medium-format camera in use. It's simple, well-made and will last a lifetime. Although ideal in the studio, it's a little too big and cumbersome for location work.

Autofocusing can be invaluable for sport, action and news photography, but it's by no means essential. Before the advent of AF technology, photographers had been taking wonderful photographs for decades with much simpler manual focus cameras, so if they could do it, so can you. I still use a manual focus system based around two Olympus OM4-Ti bodies, as I find these cameras incredibly robust and reliable, as well as being compact and easy to use. There is very little that can go wrong with them compared with the latest electronic machines which are completely battery-dependent – this is an important consideration if the camera is going to be used regularly.

Bigger is better

Most freelance photographers also invest in a medium-format system at some stage. If you intend shooting weddings and studio portraits or entering the industrial/commercial arena, this will be necessary straight away. Medium-format is also required if you want to break into the calendar publishing world, or try to get commissions from many magazines.

Opinions are split about which medium-format size is actually best. Many photographers prefer the 6x4.5cm format, as the cameras and lenses are relatively small, light and inexpensive, so they handle well, and you get 15 frames on a 120 roll film, so the cost per shot is quite low. This size is generally accepted by people who require medium-format, but personally I feel it's too close to 35mm in terms of image size.

The well-established 6x6cm format is still used by some wedding, portrait and studio photographers and is the traditional medium-format size. However, its square shape can make composition tricky when shooting landscapes, architecture and so on, and the original image is invariably cropped to a rectangle. For this reason, many freelancers have now switched to 6x7cm, as its rectangular proportions form a good shape

to compose in, image quality is superb, and it is the preferred format for stock photography.

Which system should you buy? Well, that again will be governed by needs and budget. If you want a cheap introduction to medium-format, buy a secondhand Mamiya twin lens reflex camera, such as the C220 or the more expensive C330. They can be bought very inexpensively, and offer the advantage of interchangeable lenses. The design may seem rather antiquated, but you'll quickly get used to it – I started out with a Mamiya C220, and it produced superb quality 6x6cm colour slides.

For those of you with more money to spend, modern systems from Mamiya, Bronica, Fuji, Pentax and Hasselblad are worth considering.

Probably the most popular studio camera used by portrait, fashion, still-life, advertising and editorial photographers is the Mamiya RB67, a robust, simple workhorse that's built to last a lifetime, or its updated brother the RZ67, which offers all the same benefits with the addition of electronic features. Both make superb studio cameras as they have a bellows focusing system which allows you to work at close range, interchangeable film backs and viewfinders, plus a novel rotating back system which allows you to switch from horizontal to upright format by twisting the back, instead of turning the whole camera on to its side.

In the smaller formats, models such as the Bronica ETRSi and Mamiya 645 Super (or their earlier variations) offer similar versatility, along with the Bronica SQAi and any Hasselblad for 6x6cm format.

On location, all the cameras mentioned above can be used. However, if you intend walking long distances with a full system, then something more compact will be preferable. I use a Pentax 67 for location work, a 6x7cm model that looks and handles like an over-sized 35mm SLR. It's very simple, with no integral metering, but incredibly solid and the lenses offer superb quality. Fuji rangefinder models are also ideal for landscape

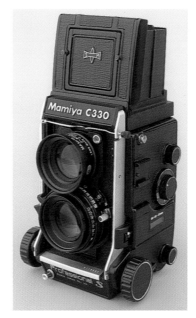

If you would like to shoot medium-format images but cannot afford a modern camera model, old-fashioned TLR (Twin-Lens-Reflex) cameras such as the Mamiya C330 make a great alternative and can be bought cheaply on the secondhand camera market.

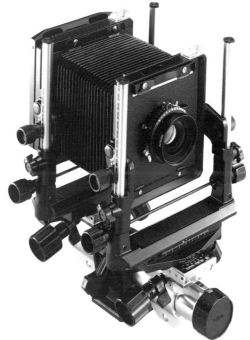

Large-format equipment is only really necessary for certain specialized areas of photography, such as architectural work, studio still-life and some advertising campaigns that demand the highest possible image quality. For the jobbing freelancer, it's njce to have the option, but by no means essential – especially in the beginning.

work – they are currently available in 6x4.5cm, 6x7cm, 6x8cm and 6x9cm formats.

In terms of lenses, you should find that you can cope with just about all eventualities using either a wide angle, standard or short telephoto. A typical system for the 6x7cm format would comprise 55mm, 105mm and 150 or 180mm. Rarely will you need anything else in the studio or for weddings, while for stock photography a 2x teleconverter may be useful for extending the power of the longest lens.

Large-format is tempting, but unless you really need it, resist. Equipment costs are comparable with medium-format, often cheaper, but material costs are high and the cameras are slow to set up. If you intend specializing in commercial/industrial

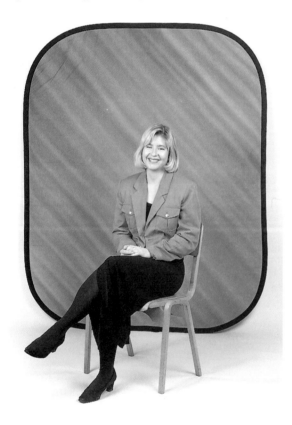

If you offer a mobile portrait service, some form of portable background system will also be useful for those situations where the existing backdrop is unsuitable.

work, particularly architecture and still-life, then at some point it's worth investing in a 5x4in system as many clients will expect it, but otherwise it's unnecessary. Large-format slides may look highly impressive on the lightbox, but for stock and editorial photography, medium-format is big enough to make your work saleable to just about everyone.

Essential items

Other essentials include a tripod – I have three models for different uses: a lightweight Manfrotto 190, which is ideal for carrying around all day when shooting on 35mm, a Benbo Mk1 for general use with 35mm or medium-format, and a bigger Gitzo when I need optimum stability.

A handheld exposure meter is also invaluable for ensuring perfect results in all conditions. Buy an ambient/flashmeter so you can use it in the studio and outdoors – models from Minolta, Gossen and Sekonic are the most popular. I use a Minolta Autometer, plus a Pentax Digital Spotmeter on location for obtaining perfect exposures in tricky situations.

Studio work requires some kind of flash system. For people, still-life and general packshots, three heads with stands, brollies or softboxes and a snoot will be more than sufficient, and as you will be working at close range, the heads needn't be too powerful. Look at systems from Bowens, Prolinca, Elinchrom, Multiblitz and Courtenay, ideally with an output of 250–500 joules. Architectural photographers tend to go for more powerful heads, but you can always employ mutiple flashes to build up the light levels if your heads won't provide enough light in one burst.

What else? Well, a portable flashgun is useful for fill-in outdoors, grabbed shots indoors, or general news photography. A gun dedicated to your camera is ideal as it will give perfectly exposed results with the minimum of fuss. Hammerhead guns such as the Metz range are

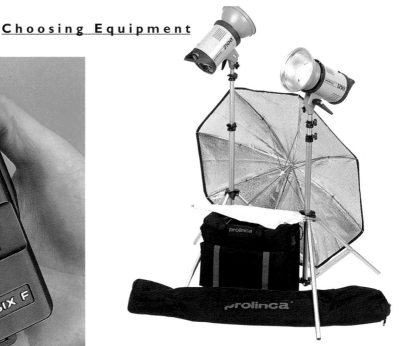

A basic lighting system such as this Prolinca kit with brollies and carrying cases is all you really need to start a mobile portrait service which involves taking pictures in the client's home.

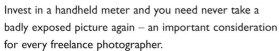

Invest in a handheld meter and you need never take a badly exposed picture again – an important consideration for every freelance photographer.

still popular among press and editorial photographers, but more freelancers are seeing the benefits of buying a model from their camera manufacturer's range as the level of dedication is more sophisticated. If you use a Canon EOS SLR, for example, one of the Canon Speedlite flashguns will be invaluable, while Nikon users can benefit from the latest SB model (at the time of writing the SB26).

Other accessories worth considering are two or three folding reflectors for use indoors and on location, plus a filter system comprising 81 series warm-ups, 80 blue and 85 orange colour conversion, one and two stop grey grads, plus a good quality polarizer and any others that are necessary for your chosen field. The most popular filter range is the Cokin P system, which offers good quality at an affordable price. However, if you're using expensive lenses, then it makes sense to use the best filters you can afford.

Film choice

A vast range of film is available today, but if you asked professional photographers and picture editors to name their favourites, you would inevitably find the same six or seven names cropping up time after time.

Firstly, you need to choose the right medium. For anything connected with publishing, be it books, magazines, calendars, postcards, advertising campaigns, brochure and stock, colour slide film is preferred as it's easier to handle and gives superior image quality. With portraits, weddings, news photography and some

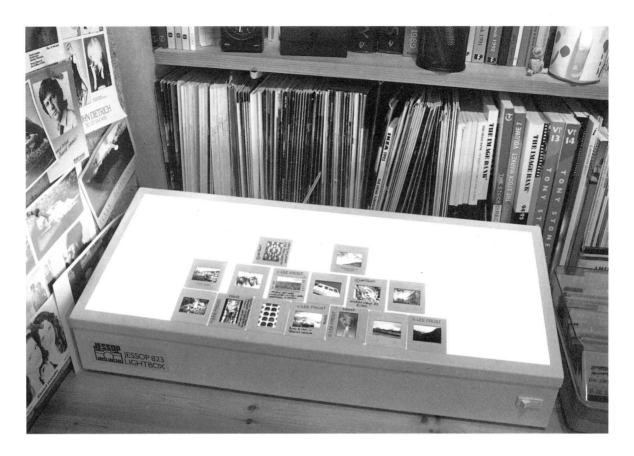

A desktop lightbox is invaluable for editing and viewing slides, so put one on your priority list. A wide variety of models is available, to suit all budgets and needs.

commercial jobs, depending upon what the pictures will be used for, colour or black and white negative film is required as you need prints to look at and they are cheaper to produce from negatives. If you're ever unsure which is required when undertaking an assignment, check with the client.

In terms of specific brands, for stock photography and location work where you require ultimate image quality, colour saturation and fine grain, Fujichrome Velvia is used almost exclusively, and tends to be the first choice for picture libraries, calendar publishers and many magazines. However, as this is a very contrasty, punchy film it can be a little over the top, especially when photographing people, as skin tones appear too warm. In these situations, Fujichrome Provia 100 tends to be used instead as it provides more neutral colours while still offering excellent resolving power. Popular alternatives include Kodachrome 64 Professional

and the Kodak Ektachrome ranges which have a wide variety of emulsions with slightly different characteristics. My advice is to try a selection and see which you prefer. That way, you can change brands for different jobs when you need a certain effect, be it vibrant colours, low contrast, ultra fine grain and so on.

For work requiring colour negative film, most freelancers use professional emulsions as they're more consistent. Kodak Vericolor VPS, VPL and VHC and Fujicolor NPL and NPS are the most popular medium-format brands used by commercial, industrial and social photographers, with the 'S' versions being used for short exposures, with flash for example, and the 'L'

being used for longer exposures. Other options include the Fujicolor Super G Plus range (ISO100, 200, 400 and 800), Kodak Ektacolor Gold 160 and Kodak Ektapress (ISO100, 400, 1600) – Ektapress and Fuji Super G are now used widely by press photographers.

On some occasions, you may be asked to take black and white pictures. For ultimate quality, Agfapan 25, Ilford Pan F and Kodak Technical Pan are hard to beat. However, in most cases you'll find that an ISO100 material such as Agfapan 100, Kodak T-Max 100 or Ilford FP4 Plus (ISO125) is more than adequate. The latest crop of ISO400 films are also surprisingly good, and tend to be chosen for general use by many photographers – Ilford Delta 400 or HP5 Plus, Kodak T-Max 400 and Agfapan 400 are the best available. If you need to shoot black and white but don't have a darkroom, load up with Ilford XP2, which is an ISO400 film that's C-41 compatible and can be processed like colour negative film at your local laboratory. It also offers superb sharpness and fine grain, so big enlargements can be made without losing quality.

Your aim when shooting pictures for sale should always be to offer the best possible image quality, so stick to the slowest possible film in any given situation. Indoors or out in low light, this may sometimes mean loading up with a faster film, such as ISO400, even ISO1600. However, today's fast films offer superb quality, so this needn't cause problems. The faster films in the Fujichrome Provia range are particularly good for colour slides, while Fujicolor Super G Plus 800 is widely used by sport and press photographers.

An alternative when more speed is required is to uprate slower film then push process it. This technique is often used by sport and press photographers as it means they don't have to carry lots of different film types. Also, some slower films give better results when pushed two stops than the faster films in the same range. Fujichrome Provia 100 pushed two stops to ISO400 is notably better than Provia 400, for example, while most ISO400 black and white films offer finer grain when pushed to ISO1600 than actual ISO1600 films.

You can also use fast, grainy films for creative effects. Many portrait photographers offer a 'pastel portrait' service, for example, which involves using grainy film, soft focus filters and warm light to produce beautiful romantic effects. Here the grain is a benefit rather than a drawback. For colour slide work, Agfachrome RS1000 and Scotchchrome P800/3200 are good choices, while for colour prints, Fujicolor SHG1600 and Agfacolor XRS1000 are popular, along with Fuji Neopan 1600 and Kodak T-Max 3200 for black and white.

When buying film, it's better to invest in quite large batches rather than the occasional roll here and there. Not only does this mean you've always got plenty of film on hand for urgent jobs, but often you can benefit from bulk discounts. I have a second refrigerator in my darkroom at home which is used for film storage and is always well-stocked with a range of emulsions.

Buying secondhand

Investing in equipment can be an expensive pastime, so any way of saving money is always welcome. Over the years, I have found that buying secondhand makes a lot of sense. Photographic equipment depreciates rapidly, so if you shop around it's possible to buy the items you need at a fraction of the new price, with hardly any signs of use or wear. Just about all my equipment has been previously owned by someone else.

I tend to buy from high street dealers rather than professional suppliers as the equipment has invariably come from amateurs, so it has probably been well looked after. Most secondhand cameras are unlikely to have been used intensively, whereas the same item from a professional will have been employed almost daily and had a much harder life.

The secondhand market can be especially fruitful if you still prefer traditional manual focus equipment, as most amateurs are busy shedding their SLRs and lenses in favour of the latest autofocus kit. You can also get hold of some excellent medium-format equipment at bargain prices. The Mamiya TLR system I used to own is still readily available, and you can buy a body and kit of three lenses for less than it would cost to buy a single lens for a more modern model.

Of course, I don't just accept what's offered. Cameras are tested by shooting a roll of film and having it processed, to ensure the metering system and everything else works well, lenses are given close inspection to check for scratches or scuffing on the front and back elements, plus dust or mould growth inside. Without exception I also haggle on the price as most dealers are willing to be flexible if they see you're interested. I can't remember the last time I paid what was being asked.

The option to buy

There will no doubt come a time, either now or in the future, when you have to face the prospect of either investing in a completely new system or buying an expensive addition, such as studio lighting, a large-format camera, or an exotic lens. But how, exactly, should you buy it? By paying cash? On hire purchase? With a bank loan? On a lease-buy deal? On your credit card?

All are viable options, but think carefully before choosing one. I spoke to my accountant about this, and her comments were very interesting.

Basically, if you have the money to pay cash for the item, do so. This eats up capital, but at least you don't pay interest. If you can't afford to pay cash then you have three options: a finance agreement, a bank loan or a lease agreement.

If you can manage to find a zero per cent interest-free finance deal, or a low interest deal, this can be the cheapest option, as bank loans

tend to incur quite high interest rates. This just leaves the lease option. Many professional dealers now offer this kind of scheme, and it basically means you lease the equipment for a set period - for example, three years - then at the end you have the option to send it back or buy it for a small percentage of the total value.

While the equipment is being leased it should be covered for servicing, repairs and breakdown, so you don't have to worry if anything goes wrong. At the end of the agreed period you may then decide to send the gear back and start again - by that time it should have paid for itself. If not, you can pay the agreed sum and it becomes yours.

Ultimately, the option you choose will depend on your financial circumstances, but all should be given serious consideration before a decision is made, along with your reasons for buying new equipment in the first place.

Insurance and servicing

Once you start operating as a freelance photographer you also need to treat your equipment differently. For a start, most amateurs have their cameras and lenses insured on a house contents policy which covers them at home and abroad. However, if you are working as a professional photographer this cover may become invalid. Check this with your insurance company, and if necessary take out a new policy. You could do this with the same company, or take out a special photographic insurance policy - details of which can often be found in the photographic press.

The extent of cover required depends on the type of work you do. If you intend travelling overseas regularly, worldwide cover will be necessary, whereas if you will only make the occasional trip abroad, you could have the equipment covered for your home country then get the policy amended as and when required. You should also update the policy whenever new equipment is purchased, as many insurance

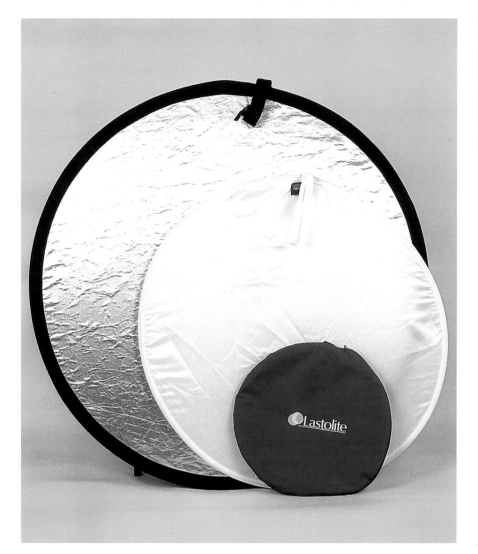

Folding reflectors like these Lastolite models are invaluable for portrait, wedding and general social photography, so be sure to include them on your shopping list.

companies require details of items with a value over a certain amount.

Another consideration is public liability insurance. This will be required if you operate as a social photographer, so you will be covered in the event of an accident to a person or property while undertaking a photographic job, or if something goes wrong and the client sues you.

Regular servicing of your equipment should also be given priority, as you can't expect cameras and lenses to work indefinitely without occasional maintenance – just like a motorcar. If you check the classified section of photographic magazines you will often find specialist repairers advertising their services. Most large camera manufacturers offer a repair and service system for professional users, often with inexpensive or even free loan of equipment while yours is out of commission.

Photographers are legendary for treating their equipment badly then complaining when it breaks down, but as a professional you can't afford to take this risk – remember, you're only as good as your last job, and if that goes horribly wrong you could find your reputation on the line.

MAKING CONTACT

An answering machine should be considered an essential item by every freelance photographer, as it allows potential clients to make contact with you in your absence. This compact model acts as both a telephone and answering machine.

A S WELL AS PHOTOGRAPHIC equipment, the active freelancer also requires various other items that are beneficial to the smooth running of the business, such as a telephone, fax, computer, and so on. Initially you can probably manage with just the basic items, but as your income from photography increases they will become useful, if not essential, and allow you to keep abreast with the technology being employed by rival photographers.

Telephones and answering machines

Just about every household has at least one telephone, and for obvious reasons, this is essential as you will need to make regular calls to potential clients. You will also need some means by which people can contact you.

A telephone answering machine is equally useful, as it gives potential clients or picture buyers the opportunity to reach you even when you're not at home. As this is likely to be most of the time if you are out taking pictures regularly, you should seriously consider investing in one immediately. Members of the public may still feel intimidated by them, but professional people leave messages daily, and will rarely be tempted to hang up as soon as the recorded message begins to play.

Mobile telephones

Back in the 1980s, mobile phones were seen as toys of the rich, famous and successful, but today a massive reduction in the cost of the telephones,

connection, line rental and airtime means they are accessible to just about everyone, and in business are standard issue. I managed for several years without one when I first started operating as a freelance photographer, but I now consider it to be an essential item as it allows people to contact me wherever I am in the country, at any time of the day or night. As a result, I have secured many commissions and have been able to respond to urgent picture requests which in turn have led to sales.

Many mobile phone companies also offer a message service, where callers can leave a message if they fail to contact you because your telephone is switched off or you're in an area where the reception is poor. By calling a special number at the end of each day, you can check to see if any messages have been left, therefore

Although you may have no use for one during the first few years of your freelance activities, a fax machine will at some point be worth considering. Most businesses, both large and small, have one these days, and it provides yet another means of maintaining contact between freelancer, client and picture buyers.

making doubly sure that if anyone needs to contact you, then they can.

If you shop around, you will find some excellent deals, with a wide variety of tariffs to choose from. Often the telephones and connection to the airwaves are provided free of charge, so all you pay is a monthly line rental fee and any airtime used.

Usually the main difference in pricing is

between business or personal tariffs. With the former, the monthly line rental fee is higher but airtime per minute is low, while with the latter the line rental is low but call charges are higher. If you expect to make many calls per month, then the business rate will probably work out cheaper long term, but if you need a mobile phone mainly so people can contact you, the personal rate is a better option. Most telephone companies require you to sign a one year contract, but after that period you can always transfer to a different tariff while keeping the same number.

telephone, for example, a message can be faxed instead so that it's waiting for you when you arrive. If this involves a lot of information, such as a 'wants' list from a magazine editor, or details of how to reach a specific location for a job, faxing that information is preferable to leaving a long message on an answering machine or giving it to you over the telephone. It also allows you to transfer information to other people quickly and easily, such as invoice reminders, captions to pictures, estimates, and so on.

In most towns and cities you will find faxing

Fax machines

This item is by no means essential, but more and more photographers are investing in them because it provides clients and picture buyers with an alternative means of relaying essential information. If you are unable to reach the

A computer system will make light work of record-keeping, generating invoices, cataloguing and captioning pictures and a whole host of other important tasks. Even the most basic models are now capable of doing all these things saving you a lot of time and effort.

agencies who can send and receive faxes for you. Most printing outlets also have a fax machine on their premises which members of the public can use. However, like most pieces of electronic gadgetry, fax machines are now available at very favourable prices, so it makes sense to buy your own – some models have a telephone, answering machine and even an in-built photocopying facility, so they serve all your needs in one go. Failing that, a compact fax machine can be purchased which takes up the minimum of space in your office or work area.

Computers

The very thought of learning how to use a computer may fill you with dread, but in reality they are not that difficult to master, and once you have passed the initial stage, you will wonder how you ever managed without one.

Modern microcomputers are amazing pieces of equipment, able to store mammoth amounts of data and process information quicker than you would think possible. To the ambitious freelance photographer they are also indispensable for a wide variety of applications, making many laborious tasks quick, easy and often quite enjoyable.

Here are just a few of the jobs my computer does on a daily basis:

* Generating copy for magazine articles and books
* Producing invoices for clients which are stored for future reference
* Producing accounts
* Writing letters/fax messages
* Producing caption labels for 35mm slide mounts using a special software package
* Keeping records of all picture submissions and printing copies to be sent out with each submission

Without a computer these tasks would take much longer. Also, by centralizing them all, I have an efficient filing system on the computer's hard disk drive and can recall anything in a matter of seconds, be it a complete list of all invoices submitted last year or a feature I wrote for a magazine five years ago.

A further benefit of being computer literate is that you can also take advantage of the advancements in electronic imaging and photo CD. If you have a computer with 16+ megabytes of RAM and 500+ megabytes of hard drive memory, you can invest in a software package, such as Adobe Photoshop, plus an inexpensive CD Rom system which then links up to the computer, and begin experimenting with image manipulation.

There are now many agencies in operation which will scan existing pictures on to photo CDs, so you can then call them up on your computer screen, and using the imaging software do more or less anything you like: remove unwanted or distracting features from a shot, change the colour of the sky, combine more than one image and so on. The potential is limitless. Once the results are satisfactory you can then copy the file on to a high density floppy disc and either supply it in that form or have a colour transparency generated.

This may all sound like something from a science fiction movie, but it really is happening. Many of the world's leading picture libraries now have the ability to supply catalogue images on photo CD, many publishing houses are investing in the hardware required so their designers can view and use those images, and more and more photographers are becoming involved in the creation of digital images.

The way technology is advancing, it seems like the use of conventional film by publishers will diminish rapidly over the next few years. This does not mean it will disappear altogether, so there is no cause for concern, but it does mean that photographers who keep abreast of these developments will be better placed to benefit.

RECORD KEEPING

ONCE YOU PRACTISE as a freelance photographer, no matter how large or small your income from it is, you are running a business. The knock-on effect of this is two-fold. Firstly, by law you are required to keep records of all business transactions, whether it's money you have earned from your photography or purchases you have made in order to carry out photography on a professional level. You also have to prepare accounts that reflect this activity, and submit them to the relevant government body for tax affairs in your home country (in the USA it is the IRS, for example) so they can be assessed and any tax paid. (Depending on the type of work you do, or the level of income it provides, in the UK you may also need to register for VAT.)

Secondly, in order to maintain the smooth running of your business, you are advised to establish some kind of filing system which keeps

No matter how simple it is, some kind of filing system for invoices, receipts, bills and the many other important pieces of paper you will always accumulate as a freelance photographer, is essential.

records of things such as picture submissions, commissions undertaken and leads to follow-up, so you can maximize on the sales potential of your work, and know exactly who holds what.

This side of running a business is probably the least interesting so many photographers tend to ignore it. However, to do so is dangerous, as you can soon find yourself in a complete mess, not knowing how much you've earned, how much you've spent or where your pictures are. From a legal point of view you could also find yourself paying far more tax than you really need to, missing out on the many financial benefits that come from being self-employed, or worse still, breaking the law and having to suffer the consequences.

Many businesses fail through poor financial management and record-keeping, so if you establish an efficient system from day one, you should never find yourself suffering such a fate.

First steps

As soon as you start operating as a freelance photographer, there are several things you should do to get the business off the ground.

1. Open a business bank account

It's tempting to use your personal bank account for your freelancing activities: depositing any income it generates; writing cheques to pay for materials, equipment and other items such as stationery and postage. However, you will be much better organized if you open a separate account just for your freelance business, no matter how infrequently you use it.

There are several advantages to this:

* Once you have one, it's ready and waiting when your business begins to grow.
* It allows you to keep track of how much you're earning and how much you're spending as a result of your freelancing activities.
* It keeps your personal and business finances separate. If you use just one account, it's easy to spend personal money on business expenses, or business money on personal expenses, and end up in a muddle.
* Keeping accounts is much easier, as all business transactions will appear on your bank statements and you do not have to sort them out from all your other income or expenses.
* It gives you access to certain benefits with your bank, such as introductory free banking, preferential deals on business loans, etc.

2. Contact the governing tax body

Write to your local office – you will find it in the phone book – and tell them you are now operating as a part-time or full-time freelance photographer, giving a date for the start of your business. They will then enter the business on to their records, provide you with literature on taxation and keeping accounts and send a tax return form to you each year in which you detail the financial side of your business activities.

3. See an accountant

As soon as possible, talk to a qualified accountant. If you don't already know one, or know someone who does, choose one from your local business telephone directory and make an appointment – most will give you the first 30 minutes or an hour free of charge.

Explain that you have just set up in business as a part-time freelance photographer, then discuss the type of work you will be doing, how much you expect to earn, what you will need to spend and so on.

If you don't expect to do much business in the beginning, then it's not worth employing an accountant for day-to-day activities. Instead, offer to keep your own accounts, but use the accountant to assess them for tax purposes.

This will cost you the equivalent of perhaps two days' work per year, but it's worth it because a qualified accountant will ensure you pay the absolute minimum tax required on the income you make.

4. Create an office

To run your business smoothly you need some kind of work area that you can dedicate to it. This can be tricky if you are working from home, but it really is important to establish office space that can house all your photographic equipment, pictures, accounts, records and anything else that's relevant to the business. This is important not only so you know where everything is, but also so you have an organized area in which to work, and which other members of the family know is out-of-bounds.

I use the spare bedroom in my home, which only measures about 6x9ft (2x3m), but is more than adequate. In that space I have written several books, hundreds of magazine articles, and made

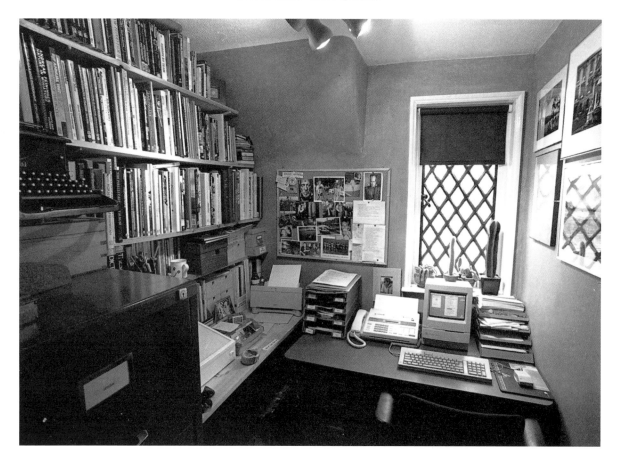

thousands of picture submissions. It holds my computer, lightbox, telephone/fax/answering machine, hundreds of books, approximately 20,000 colour transparencies and all my photographic hardware.

It took some time to achieve the level of organisation required to store everything, but now I have established a comfortable, cheerful office environment in which I can work in complete quiet and isolation.

Keeping accounts

If the prospect of keeping records of all your financial affairs makes you break out into a cold sweat, don't worry – we've all been there. The good news is, keeping accounts isn't as difficult or as time consuming as it sounds providing you

Some kind of office space in your home will be necessary once your freelance business begins to flourish. This picture shows the author's 'den', which started life as a spare bedroom but is now a well-planned and comfortable work area.

establish a system right away and you update your accounts regularly.

Here's a brief explanation of the system I operate – so far it has served me well through almost a decade of freelancing, initially on a part-time basis, and now as a full-time business.

The heart of the system is a simple 'concertina' file which has around two dozen pockets to store everything I need. Each pocket has a different heading so I can keep everything organized –

these include: receipts, invoices paid, invoices outstanding, bank statements, cheque book stubs, new bank books, tax information and records, car details, credit card receipts and statements, etc. Whenever a piece of paper is generated, for whatever reason, it is immediately filed into the appropriate pocket for future reference.

* When pictures are sold or a photographic commission completed, I generate an invoice on my computer, print out one copy on headed paper to send to the client, and a second copy on plain paper. The second copy is filed in the 'Invoices outstanding' file, then once it's paid, I clip any payment slips to it and transfer it into the 'Invoices paid' file. This means all invoices are automatically filed in date order, which makes linking them to bank statements and logging them in my accounts book much easier. I can also check periodically to see which invoices are still outstanding, and send a reminder to the client.

Invoices should include all relevant details: the client's name and address, the date, an invoice number (I use a numerical system of the year followed by the invoice number for that year – 96/105, for example, refers to invoice number 105 for the year 1996). Also include a detailed breakdown of the charges so the client knows exactly what they are paying for: the number of rolls of film, the cost of processing, your time, and any other expenses, plus to which job the invoice relates.

* All receipts for purchases/expenses associated with the business are stored in my wallet, then every week or so (usually when the wallet reaches bursting point) they are transferred to the receipts pocket of my filing system.

Once you start operating as a freelancer, keep receipts for *everything* associated with your photography: cameras, lenses, film, processing,

travelling expenses such as petrol, air tickets, car maintenance and other bills, all insurance, hotel bills, telephone bills, meals, stationery, postage, pens, pencils, printer cartridges, computer discs, and anything else you can think of. If in doubt, keep it, and let your accountant decide whether it's tax deductible – I even account for items such as outdoor clothing and footwear as I specialize in landscape photography, so these things are essential to my job.

It is vitally important that you keep receipts as you cannot claim tax relief on anything unless a receipt is available.

* Every month I update my accounts book (see below), so that the backlog of receipts and invoices isn't too big. That way, I don't have to spend too much time on accounting, and by the end of the financial year when my accounts have to be submitted, they're all but complete.

* After each year, all records associated with the financial side of the business are placed in a box file and stored away after my accountant has finished with them. This is necessary by law – all accounts for the previous six years must be kept. Check with your own tax office for variations if you live outside the UK. These files include: invoices, receipts, bank statements, bank books, credit card receipts and statements.

* Whenever possible I use my credit cards to make purchases. The simple reason for this is that it cuts down on the number of cheques I need to write, and therefore reduces charges incurred by my bank. It also gives me several weeks of interest free credit, and can help in times when the cash flow has hit a rough spot.

The actual system I use for keeping accounts is known as 'Double-Entry Book Keeping', and

tends to be the most common method used by people running a small business.

As the name implies, this involves entering all business expenses twice, so they can be analysed in more detail. To do this, you need a proper accounts books which has lots of rules columns in which to enter figures - you can buy them from all good stationers.

A typical layout for each double page spread would be as follows:

1 Use the first half of the left hand page for bank deposits - your **income.** In this section you need the following columns: date, invoice number, amount net, VAT, total amount. If VAT does not apply to you, then just have a total amount column. This section will then provide all relevant information on your income: when each deposit was made, which invoice it related to, and how much it was for.

2 Use the second half of the left hand page for details of withdrawals from your account - **purchases.** The columns should be headed: date, receipt number, amount cheque, cheque number, amount cash (use this column for credit card purchases as they will not appear on your bank statements, and for direct debits or standing orders, which appear on your bank statements but not in your cheque book), VAT (if this applies). This section provides all details of withdrawals from your business account.

3 The right hand page should be used to analyse those withdrawals. The column headings you use will depend on the type of work you do, but examples might include: photographic equipment, film, processing, postage, stationery, car, travelling, telephone, credit card payments, insurance, pension fund, miscellaneous, petty cash, personal drawings.

When a purchase is entered on the left hand page of the book, this amount is then analysed across and broken down if necessary. You may write a cheque for a new camera lens and several rolls of film, for example, in which case the cost of the lens is logged in the 'Photographic equipment' column, and the cost of the film is logged under 'Film'. (If you are VAT registered, the amount on this page should also be net - in other words, with the VAT removed.)

4 The petty cash column needs further explanation. Basically, when you run a business, sometimes it is necessary to have cash available - to pay for postage, buy envelopes, feed a parking meter, or buy lunch when you are out on a job.

To do this, you draw 'petty cash' from the bank account, and to keep records of purchases made with this cash, you also need to keep a second petty cash accounts book - a small accounting book will be fine.

The accounting system used for petty cash is the same as for the main accounts. When you draw money from the main bank account, this is logged into the 'Deposit' section of the petty cash account. Purchases with that money are then logged and analysed in the same way, and petty cash receipts numbered and stored separately from the main receipts.

5 When it comes to logging your receipts into the accounts books, they should first be sorted into date order and given a number - 1, 2, 3, 4 and so on. I also clip the receipts for each month together after logging, so they don't get mixed up and cause confusion.

If you follow this, or a similar system of accounting, your life will be made much easier. When the time of year comes for your accountant to call in your accounts, they will be ready and

waiting, instead of you desperately rushing around trying to get them completed. Having an efficient accounting system is also necessary in case of an inspection by a tax official – if they can't see evidence of proper book-keeping, your tax benefits may be cut, or you could be forced to pay a financial penalty.

If your income from photography is expected to be very small, this may seem like a waste of time and energy. However, financially it makes a lot of sense because even if you don't actually make any sales, you may still be able to claim tax relief against the expenses you incur in the process of trying.

Picture files

Having your pictures organized into some kind of logical system is important when you're operating as a professional photographer. Not only does it mean that you can keep track of where everything is, but it's also much easier to locate individual pictures quickly. This may not

Slides are best stored in transparent file sheets which can be hung on suspension bars in a filing cabinet. A typical office cabinet will hold thousands of slides in each drawer.

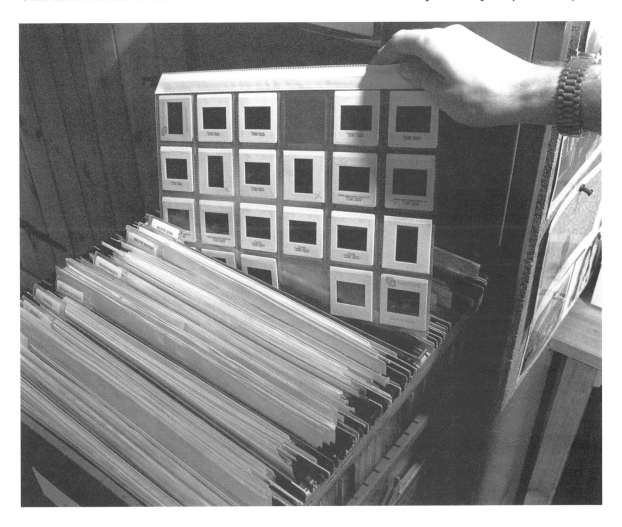

Detailed caption lists of pictures should accompany every submission that is made – not only so the recipient has sufficient information at hand, but also so there can be no confusion about what has been sent.

seem too important now, but in a few years you may have several thousand pictures, both slides and prints, and locating a specific shot can take hours if your files are not organized.

This is one subject that I hate with a passion; however, I do have a rather crude system in operation which works perfectly well. My specialist subject is landscape and location photography, so I simply break down the pictures into locations. As most of my pictures are landscapes or landmarks, I file by county or city. If one county file becomes too large then I divide that further, into specific towns and villages.

For overseas destinations, I file by country as I rarely have more than a few hundred pictures for each foreign location. I also have one-off files for subjects such as abstracts, skies, still-life, people, action, close-ups and so on. The same system is used for both 35mm and medium-format colour slides, which I file separately.

The slides are stored in transparent file pages which hang by suspension bars in a steel four-drawer cabinet. Each sheet holds 24 mounted 35mm slides or 4 medium-format slides mounted in 5x4inch black card masks with polyester slip-over protective sleeves. When I receive a request for pictures, all I have to do is select the correct category in the filing cabinet and remove a selection of images.

At this stage, it is tempting to drop the slides into an envelope and post them to the client. However, if you do, you will not have any record of the pictures, how many were sent, when they were posted, and to whom. With many similar submissions in circulation at any one time, it then becomes very easy to forget about the occasional one or two, and before you know it, you have effectively 'lost' those pictures because you haven't got a clue where they are.

Prevent this by keeping a photo submission record. At its simplest this need only be a notebook with ruled pages into which you log important details such as the date, name of client, number of pictures sent, brief description of those pictures and any other important details. Periodically, you can then refer back to the book and chase up any pictures which have been out of your files for a while.

A better method is to type out a full list of the pictures sent so you can send one with the pictures in the form of a delivery note and keep one on file. It's even possible to buy these as self-carbonating pads – a worthwhile investment as they look very professional and set out the conditions of use for the pictures, such as the amount the client will have to pay for loss or damage. That way, if a submission is returned with pictures missing, you can immediately identify which ones these are and make enquiries as to their whereabouts.

Taking the idea even further, many professional photographers give each slide a reference number which is logged on the delivery note and kept on file so there can be no disputing who has what. There are many different ways to do this. However, if you adopt a category filing system, probably the best way is to use some kind of code for the category; eg, USA for the United States of America, or LS for Landscapes, followed by a number for that specific slide. LS/475, for example, would be slide number 475 from the landscape file in the collection.

To make life easier, some computer software packages for picture filing allow you to combine all these things, so you have an effective cataloguing, cross-reference and record-keeping system. As new slides are added to your files, their reference number and caption is entered into the computer database. When a picture request comes in, all you have to do then is enter key words into the computer, such as 'Statue of Liberty', or 'Sunsets', and the computer will search the database to locate all reference numbers of slides of those subjects. As specific slides are removed you can log their reference number into the record system, then print out a full list of all the shots removed, complete with date, time, reference numbers, caption details and to whom they are being sent. This efficient and foolproof system is ideal for freelance photographers making regular submissions to publishers, and allows you to regulate the whereabouts of every picture that leaves your home.

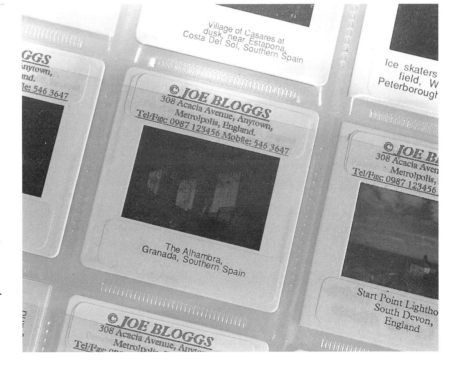

Make sure all your slides are fully captioned and show your name, address and telephone number before leaving your files. I use a popular computer software program which produces neat slide labels quickly and easily.

PHOTOGRAPHIC COPYRIGHT

F EW PHOTOGRAPHERS HAVE a complete understanding of copyright legislation and its implications, but once you start operating as a freelancer it becomes vitally important – otherwise you could suffer financially, or find yourself at the wrong end of a legal battle.

In the UK, the most recent copyright act for photographers was drawn up in 1988, but immediately certain clauses in it caused problems, and amendments were made soon afterwards which are still in force. The British Photographers' Liaison Committee also keeps abreast of developments on copyright, and produces literature which explains the implications as simply as possible to both photographers and their clients.

In Europe, North America, Australia and other countries throughout the world, the terms of copyright may vary, so if you live outside the UK, or intend working overseas, you are advised to obtain details of the relevant copyright act before starting out.

Whenever you take posed pictures of people on a professional basis, your subjects should be asked to sign a model release form which gives you permission to offer the pictures for publication or other uses without risking legal problems.

The basics of copyright

Copyright legislation exists so that the work generated by photographers, writers and artists is protected by law, thus preventing unauthorised reproduction of that work without the prior permission of the author, and ensuring some kind of economic deal is struck which pleases all parties involved. It also states that you have the right to be identified as the author of that work, and that it cannot be subjected to 'derogatory treatment'.

In other words, if you take a photograph which is published, you have a right to be paid by the publisher a suitable fee for its reproduction, and the right to be identified as the creator of that

picture in the form of a credit or 'byline'.

Similarly, it also protects the client in so far as if you assign copyright for a particular image to them, then you are in breach of copyright and liable to a penalty if copyright for the same image is assigned or licensed to another client.

Traditionally, photographers have been seen as inferior to artists and writers in terms of copyright, and over the decades have had to overcome innumerable problems in an attempt to receive fair recognition. In Britain for example, before the 1988 Copyright, Design and Patents Act appeared, the copyright of a photograph belonged to the person who provided the materials – the film – on which it was taken. So, if you undertook a commission for a client and they supplied the film, the copyright of all the pictures you took automatically became theirs. Fortunately, this was changed in the new act, and today, if you take a photograph you are considered the 'author', whether it was commissioned or not.

The only exception to this is if you are an employed photographer, in which case the photographs you take as part of your regular job are the property of your employer. As freelance photographers by nature don't fall into this category, you needn't worry about it.

Some picture libraries require a property release form for photographs of private buildings before they will accept them on to their files. If you intend supplying stock images of such subjects, you should therefore check if this is necessary with your library.

Assignment of copyright

At some point in your career you may complete a commission for a client and be asked to assign copyright to them by signing a contract. Unless you have a good reason for doing so, such as being offered what you feel is a fair financial settlement, avoid this as you could lose out in the future.

The size of this settlement will depend on the client's reason for requesting that copyright be assigned to them. If they intend using the picture repeatedly in future brochures, say, then you should agree a fee for each repeat use. The same applies if they intend syndicating them to other companies, or using the pictures for publicity purposes. If future use can't be specified, then insist on retaining copyright and negotiating fresh deals for every subsequent use of the pictures – and make sure everything is in writing so there can be no confusion about what has been agreed.

If you do decide to re-assign copyright to another party, remember they become the owner of those images in their entirety for all time, so you no longer have any claim on revenue generated from further sales. However, by

retaining copyright, simply by refusing to sign it away, even if the client holds those images on their own property they must still seek your permission to sell them, and agree a financial payment to you from any sales revenue. Legally, they must also provide you with access to those pictures so you can offer them for sale yourself, although maintaining this can be difficult, so whenever possible, insist on holding the pictures on your own files.

As an example of how this can work, it is not uncommon for magazines to run their picture files like a stock agency and generate extra profit by selling images to advertisers, book publishers and so on.

If some of those pictures were taken by you during commissioned jobs for that magazine, then by law you are entitled to a share in the profits. However, if you assign copyright for those pictures to the magazine's publisher, you are not entitled to anything. Over a period of time, this could mean you miss out on healthy reproduction fees that come in.

In the UK, some of the bigger publishing houses are recognising the fact that existing picture files can provide a lucrative sideline. As a result, some are now considering drawing up contracts with photographers who undertake commissions for them which automatically assigns full copyright of any pictures taken to the publishing company.

These changes are still in their infancy, but you should be aware of them, and read carefully any contracts you are asked to sign before accepting a commission, otherwise you could lose copyright without realising it, and once a contract is signed it immediately becomes legally binding.

If you are faced with this problem and are put in a situation where you sign or lose the work, consider your next move very carefully, explain the subject of copyright to the client, and at least negotiate a higher rate for your services to account for the potential loss of future earnings. This is a difficult one because any work is better than no work, but at the same time professional photographers should protect their rights.

Copyright duration

The assignment of copyright to a photographer's work isn't just a short term arrangement – it lasts throughout that person's life, and for a long time after their death. At some point in the future, members of the European Union will publish new guidelines for copyright duration that will be common throughout all member states, and it is suggested the duration will be increased to 70 years after the photographer's death. However, this is not the case at present in Europe, and these changes will not affect countries outside the European Union.

Here are some current examples of copyright duration:

AUSTRALIA	50 years from year end of taking or publication
CANADA	50 years from year end of taking
FRANCE	50 years after death of photographer, and in some cases an additional 30 years 'for serving France'
GERMANY	70 years after death of photographer for photographic works; 50 years from year end of publication, or time of taking if not published, for documentary photographs; 25 years from year end of publication, or time of taking if not published, for 'simple' photographs
IRELAND	50 years after death of photographer or 50 years from year end of publication
ITALY	50 years from year end of taking for photographic works; 20 years from year end of taking for 'simple' photographs
NEW ZEALAND	50 years from year end of taking

If you have a highly saleable picture, it is tempting to offer it to as many markets as possible so you can maximize its sales potential. While there is nothing wrong with doing this, you should take care not to offer the same picture to rival markets at the same time, otherwise you could upset all parties involved and find yourself black-listed. If copyright for that picture has already been assigned to one client, you could also find yourself facing legal proceedings.

SPAIN	60 years after death of photographer; 25 years after year end of taking for 'simple' photographs
UNITED KINGDOM	50 years after death of photographer
USA	50 years after death of photographer

Obviously, because copyright remains with the photographer for so long after their death in many countries, it is important that a will is drawn up which names an individual to whom copyright can be re-assigned. If this is not done, then copyright for all your photographs could be deemed part of your estate and automatically be bequeathed to the legal beneficiary.

As your photographs may have more earning potential after your death than before it due to the duration of copyright, it makes sense to assign copyright in your will to someone who is not only willing to accept the responsibility for your work, but have the ability to make use of it.

Stock images held by a picture library can obviously stay with the library and any sales returns paid to the legal owner of the copyright. Or in the case of a large picture collection, the person holding copyright after your death may be able to assign someone the task of marketing the collection on their behalf.

There are many possibilities which you won't be around to witness, but it is still important that the future of your picture collection is secured, no matter how large or small it is.

Once-off rights

When a picture is purchased from a photographer or picture library for publication in a magazine, newspaper, book, poster, calendar, postcard or any other form of publication, the fee paid is usually for 'once-off reproduction rights'. In effect, this means the client has paid to use that picture once, but the copyright still remains with the photographer and that very same picture can be offered for use in other non-competing markets.

For example, if one of your pictures is

If you shoot weddings and portraits, remember that while you own copyright on the pictures, you must still seek the permission of the subjects if you want to use those pictures for publication, display or any purpose other than for what they were originally taken.

published in a magazine, you can still offer it for sale again to magazines in a non-competing field or to different markets, such as calendars or postcards. This allows you to gain maximum sales potential from your pictures.

If the same picture is used repeatedly in the same publication – perhaps in an article, as an inset picture on the cover, and on the contents page, you should also negotiate a higher payment rate. Some publishers may try to avoid this, but morally they should be prepared to pay extra for repeat usage.

Obviously, you have a moral obligation here to avoid embarrassment or problems by selling the same picture to different markets simultaneously, but if you use your commonsense, problems can be avoided. You should also weigh up the advantages and disadvantages of protesting to a client if you feel they are paying you too little. A regular client may consider a slight reduction in

reproduction fees fair as they publish a lot of your work, so to complain about this may be counter-productive. By no means should you let this cloud your judgement, but at the same time, be sensible.

In certain markets, stipulations about the assignment of copyright should also be carefully considered. In the calendar market, for example, publishers normally stipulate the length of time they wish to retain full calendar rights on an image – usually it is one year, sometimes more – and check for clearance on a picture before going ahead and using it.

Whatever the period is, you must not offer the same picture for sale to another calendar publisher until it has expired, otherwise you will

In most countries, you can take pictures of people in public places without their permission and legally there is nothing they can do about it. However, should that picture be published with a caption that suggests defamation of character, you can be sued for damages by the subject, so be careful. In this picture, for example, the subjects are taking a little nap in a park, but to suggest they were lazy holiday-makers or drunks would be libellous and could cause the photographer a great many problems.

upset both parties, and chances are they will never use your work again for fear of encountering the same problem. The publisher

first assigned copyright can also demand that the second publisher withdraws their product from the market, and if this happens, you could find yourself facing a law suit for negligence and breach of copyright.

Of course, if a publisher uses a picture without first clearing it with you, and the same shot appears in a rival publication at the same time, then the onus is on them, not you, and they can be forced to withdraw their product from the market.

Further care should be taken if you supply stock images to a picture library, but also market your own work as well. When you sign contracts with a picture library, you are effectively giving them carte blanche to market your work, within the boundaries of the copyright act, without your consent – which is why most libraries demand some level of exclusivity. If you sell calendar, poster, postcard or any other publication rights yourself, you must therefore inform the picture library of this to prevent them selling the same rights on the same picture to another publishing company.

Copyright for the social photographer

If you intend operating as a wedding and portrait photographer, the conditions of copyright are slightly different. As the 'author' of the photographs you still retain full copyright on them, but you are also limited by the rights of privacy of the commissioner of those pictures – the client.

What this basically means is you cannot offer those pictures for sale, publication, exhibition or anything else for that matter, without the consent of the people depicted in them. This even extends to the display of some of your best pictures in a shop window to try to attract more work. Before doing this, you must first obtain the permission – ideally in writing – from your client.

Equally, if the bridal couple commission a series of wedding pictures, they cannot display them in public, make reprints, offer them for publication or sale, without your permission as owner of the copyright. So, if a wedding couple ask for the negatives of their pictures, as well as the album and reprints, they are quite within their rights to do so, but if they then send those negatives to a processing laboratory for enlargement without your consent, they are in breach of copyright and you can take legal action.

One problem that is becoming more common with social photographers is the illegal copying of prints in copy shops. The improved quality of laser copiers and predominance of 'Create-a-Print' machines in high street processing shops now makes it possible to have a colour copy made from a print, negative or colour transparency for a fraction of what it would cost if you ordered reprints from the photographer. However, to do so is a blatant breach of copyright, and if you find evidence of this happening with your work you should take immediate legal action, and seek media coverage to deter other people from doing the same thing.

If you practise glamour, fashion and portrait photography, you are also advised to ask your clients, whether they are paying customers or not, to sign a proper model release form. This then gives you permission to publish those pictures and receive payment for doing so, without having to seek permission from the subject or share the proceeds with them. The only exception is if that person suddenly becomes newsworthy, in which case you cannot sell the pictures for financial gain. If you do not have a model release form but you publish the pictures, your subject could take legal action regardless of their 'celebrity' status.

Candid shots taken in the street of total strangers are usually exempt from copyright problems. There are no laws in the UK covering the right of privacy of the public; therefore, if you photograph a 'streaker' running on to a sports field, there is nothing they can do about it legally.

The only occasion problems occur is if the picture is published accompanied by defamatory text – suggesting the person was drunk or on drugs, for example. In this case, the subject can sue you for libel damages because in fact they were just having a good time. To prevent this happening you must ensure any pictures taken of people are not used in a defamatory way, especially if you do not have a signed model release form from the person photographed.

Enclosing a delivery note with all requested stock submissions is a sensible move, as it ensures the recipient is fully aware of the terms and conditions under which you operate. This prevents problems with compensation claims if pictures are lost or damaged, and reduces the risk of copyright infringement.

What you can't do

As a photographer there are few limitations on what you can ideally do. However, you need to be aware of those seemingly insignificant areas where problems may arise. Here are the most common:

* Trespass – you cannot enter someone else's property to take pictures without their permission. You can photograph most private property from a public place, but once you cross the border into private property you are breaking the law.

* Take pictures in certain places without permission. These include theatres, rock concerts, circuses, auditoria, some museums and stately homes, certain legal establishments, such as courtrooms, many government buildings and

military installations, airports (always check), and schools and hospitals.

If you do photograph any of these subjects, the copyright of the pictures remains with you, but if you offer those pictures for sale you will be in breach of copyright and legal action may be taken.

* Photograph bank notes, coins and postage stamps. This law varies around the world, but you should always check first because there may also be laws in operation to protect against copying and fraud. In most countries you must obtain permission from the relevant governing bodies.

Protecting yourself

When sending out photographs to clients, either speculatively or on request, you can cover yourself for possible infringement of copyright or loss of pictures, by following the two simple steps outlined below.

* Always make sure your name, address, telephone number, reference number and a copyright symbol (©) appears on every slide mount and on the back of every print so there can be no disputing who the pictures belong to, no excuses for not contacting you to check the clearance of a picture before publication, and no reason for avoiding payment if a picture is published. In the USA and Russian Federation the word 'Corp' is also legally recognised as an abbreviation for copyright.

* Always send out a delivery note with stock pictures. This should contain a detailed list of every picture, including a reference number for each, a clause which asserts your right to be recognised as the author of those pictures so a credit accompanies any that are published, and a compensation fee for any pictures that are lost or damaged.

Delivery notes can be purchased from most professional photographic bodies (see Section 4) and contain detailed conditions of use, as well as the information you add.

Copyright infringement – taking action

If you suspect an infringement of your copyright is about to take place, you can obtain a court order against the offender to prevent this happening. More commonly, however, an infringement isn't noticed until after the event has taken place. You may come across some of your pictures in a magazine, book or poster, for example that have been published without your consent and without a suitable reproduction fee being offered.

If this is the case, you should immediately take action. Often, a telephone call to the publisher or person responsible demanding immediate payment will be enough to settle the problem. But as they have broken the law, you should demand a fee that is much higher than you would expect if the publisher had gone through the correct legal channels.

If suitable payment is denied, seek the advice of a solicitor and take legal action against the offending party, no matter who they are. This will usually involve suing them for breach of copyright ownership. In the case of publishers, you can also take out a court order to have all copies of the products containing your work seized, be it books, posters, postcards, magazines and so on. Any individual or company with a grain of common sense will settle out of court to prevent embarrassment, loss of credibility, and the seizure of their goods.

You are advised to contact the copyright body in your home country for the current position on copyright legislation.

FINDING YOUR MARKET

THE MAGAZINE MARKET

I T SEEMS SENSIBLE TO BEGIN this section of the book with the biggest single market open to freelance photographers, and that's exactly what magazine publishing represents.

If you wander to your local store and browse at the magazines on sale, you'll see there are titles catering for every conceivable hobby, interest, social group, age and occupation. Most large countries around the world have several thousand different titles in print, and that number is increasing literally every week as new magazines are launched.

What all these publications have in common is

Analyzing specific areas of the magazine market and discovering the type of images they use is important if you want to make regular sales. The country titles are ideal for photographers who shoot landscape and scenic pictures, for example. This is one of my pictures used to illustrate a feature in a popular magazine on walking.

photography. Every single one uses pictures of some description in either colour, black and white or both. And they need lots of them – tens, hundreds even, for every issue, be it weekly,

fortnightly, monthly, bi-monthly or quarterly.

What's more, a very large proportion of them rely on freelance contributors like yourself to supply those pictures. Few magazines use staff photographers – more common is to commission freelancers as required, or to use the submissions that are made by a wide range of contributors.

Over the years I've worked on magazines both as a journalist and a photographer. As an editor, I've commissioned photographers and sifted through thousands of 'on-spec' submissions sent in by readers and aspiring freelancers. As a photographer, I've taken on commissions to photograph everything from gardens to motorbikes, and submitted stock images to magazines dealing with subjects as diverse as yachting and rearing children.

In doing this I've learned a great deal about how magazines are produced, and how to increase the chances of having work accepted.

Choosing your subject

The easiest way to start selling pictures to magazines is by submitting work to those titles which deal with subjects you are interested in, perhaps as other hobbies, simply because you'll already know those magazines well. You will already have an idea of the type of pictures they use – for instance, if they are straightforward illustrative images, or something a little more creative; if they are all colour or all black and white, or a mixture of the two. You should also know if the type of subjects covered follow a seasonal trend, if a staff photographer's pictures

Looking for new magazine outlets and making speculative submissions can be highly lucrative if you target your work correctly. I have no interest in sailing or angling, but I still manage to make sales to both markets with images that suit the subject.

LEFT AND OPPOSITE: You needn't be an expert in the subject to make sales. The key is to determine the type of pictures used by studying the magazines in a particular market, then producing work that's suitable. Seeing a need for good quality pictures in the rail market, I made a one-off trip to a railway goods yard and secured the cover plus centre spread of a popular enthusiast magazine with the pictures taken. Remember – you need to speculate to accumulate, and once sales have been made, it's much easier to follow them up with more.

are used, or if the pictures come from a range of freelance contributors.

My first published pictures appeared in photographic magazines. Once I'd reached a certain standard and I knew the pictures were actually good enough, it was fairly easy to make sales – I knew that every year there would be features on popular subjects such as landscapes, holidays, autumn, architecture, sunsets, using filters and so on. Also, by looking through back issues I could work out a pattern to when certain subjects were covered, so I could then send in work at the right time.

You may have a similar interest in gardening, hiking and camping, DIY, arts and crafts, steam trains or keeping tropical fish. The same rules apply, and you can be sure that the most successful contributors are interested in those subjects, as well as being handy with a camera.

Of course, an additional benefit of starting out with magazines with which you are already familiar is you will probably have lots of suitable pictures on file already. If not, it should be fairly easy to start producing them – all you need do is look at the type of pictures used to get an idea of what's required.

Another way of getting started is to look at the type of subjects you photograph, then set about locating magazines that deal with them. Some photographers would suggest that you'll be more successful choosing a magazine first *then* shooting pictures specifically for it, rather than finding a magazine to suit the pictures already on file. This is sound advice once you're up and running, but initially, such an approach may lead to nothing.

My main interest has always been landscape photography, so a primary target in my early days of freelancing were titles such as *Country Walking*, *Climber and Rambler*, *Heritage*, and the regional country magazines. None of them were particularly lucrative, but every sale helps and I still supply one or two of them today. You may have lots of pictures of your children on file, so you already have suitable material for parenting magazines, or you may enjoy photographing horses, in which case the equestrian magazines should be worth contacting.

Before submitting any pictures, however, it pays to analyse the magazines first so you have a clear understanding of what they need. If your pictures follow a completely different style, for example, it's unlikely an editor will suddenly make a radical change of direction to entertain them. To find these things out for yourself, browse through magazines in your local store or library, or better still, buy a copy regularly so you can keep up with any changes of editorial policy which may affect the use of photography.

Finding new markets

While doing this, it also makes sense to explore other areas of the magazine market with which you're unfamiliar. In fact, as a freelancer you should make a habit of doing this regularly -

perhaps spending an hour every week looking through different magazines to see if you can find any new outlets for your work.

Several years ago, I happened to glance through the boating and yachting magazines and found that one title in particular used a number of pictures every issue to make the letters page look more interesting. The shots were all related to boating, but featured anything from attractive harbour scenes and sunsets to details of boats.

Having lived on the coast for several years, I had lots of nautical pictures on file, so without further ado I hurried home, selected 20 or so and sent them off. One picture was used in the next issue, and since then I've had many published in the same magazine. In a similar vein, I know of photographers who have made considerable sums of money by selling pictures of everything

from interesting car number plates to door knobs and letter boxes.

To help you discover the requirements of different magazines, an annual guide is published in the UK by the Bureau of Freelance Photographers (BFP) known as the *Freelance Photographer's Market Handbook*. There is also a fortnightly newsletter available called *Cash From Your Camera*, which details specific picture requirements from many markets. Similar titles exist in the USA, Australia and other countries.

Timing is crucial

As well as knowing who wants what, you also need to know when they want it. A pretty obvious statement, but one that many photographers ignore to their cost.

There are two important things to remember that relate to the timing of your submission. Firstly, all magazines work to what are known as 'lead times'. In other words, they're put together often well in advance of the publication date. This means if you want to sell anything remotely seasonal, it must be on the editor's desk in plenty of time.

For example, if a monthly outdoor magazine is planning to run a feature on spring in the hills it will probably appear in a spring edition. However, that feature is likely to have been written during the winter, which means you need to start thinking about sending in the pictures around the same time and at least two months before the magazine goes on sale. However, don't be misled into thinking that if you submit pictures really early you can't fail to be published. You can. Taking the above feature again, for instance, if you submitted the spring pictures three or four months early, the chances are the editor wouldn't have even have conceived the feature that far back, so they'd probably be returned to you with a polite rejection slip the next day.

Once you've been submitting pictures to magazines for a while this timing will become second nature, so you shouldn't have any problems. It's still a little erratic, however, because seasonal features only account for a small proportion of the material in a magazine. So how do you get pictures used elsewhere?

Well, there are two options. The first is to make general stock submissions and suggest the editor holds anything of interest on file for possible future use. Many magazines do this as it means they've always got a large selection of good quality pictures to hand. The downside is it's easy for your pictures to lie dormant in a cavernous filing system and be forgotten about, so even though you've submitted suitable work, it doesn't get used because no one realises it's there in the first place. I know this happens because I'm guilty of doing it myself; it's just impossible to remember every picture you have on file when you see so many every day and are fighting to meet deadlines.

The way to avoid this, and to improve your chances of making sales, is to contact the magazines on a regular basis and ask for any picture 'wants'. Do not simply telephone unannounced with this request, as competition with rival magazines makes editors rather touchy about giving away such information. However, if you've already made several submissions to the magazine and perhaps made one or two sales, your name will be familiar in the editorial office, so someone will probably be willing to fill you in.

Armed with that information you can then go away and either sort some stock images from your files or, if time permits, shoot some specifically. Also, because you're submitting pictures for a specific feature and issue they will be returned when that issue has been printed, so you will not have valuable work sitting unused for months.

If this relationship works and the material you submit starts to be used, you may find that the editor or features editor telephones you with a list of requests. One thing can then lead to another, and you may find you are commissioned

to shoot pictures for the magazine and being paid a handsome rate for the privilege. I've seen this happen on photographic magazines, where in the space of a few months a reader becomes a regular contributor.

The fact is, even though photography is an overcrowded profession, there are actually very few capable, reliable freelancers who can supply the right material on time on a regular basis. So, if you are able to fulfil that brief, you could find your talents in great demand. Magazine editors are busy people – anything you can do to make their life easier will win you recognition.

Making a submission

Once you've found a magazine that wants to publish your photographs, what next?

You now need to decide which ones to send in. If you have hundreds of good shots, it is tempting to package them all up and play the safety in numbers game. But imagine what it's like for an editor to receive so much work from a photographer he's never heard of. He will equally be tempted not to bother looking at them properly, simply because it takes so much time.

So, be sensible, and for an initial submission, send no more than 20–24 pictures. You can always follow this up with more later. These pictures should be technically flawless: pin-sharp, perfectly exposed, well composed and pictorially interesting. This may be stating the obvious, but you might well be shocked by the amount of picture submissions that should have been dumped in a bin the moment they arrived back from processing.

In terms of medium, if you're submitting colour pictures they should be in slide form, and ideally shot on slow film stock. Fujichrome Velvia and Provia and Kodachrome 64 are the preferred brands these days, although the latest Kodak Ektachrome emulsions will be acceptable. Some magazines will accept colour prints, but the majority will not.

Format-wise, 35mm is fine for use inside the magazine, but some titles prefer medium-format, and just about all require medium-format for cover use. Originals should also be submitted in preference to duplicates.

Always make sure your name, address and telephone number is included on each slide mount, with suitable caption information. This can be handwritten, but printed labels look neater.

If you're submitting 35mm slides, place them in transparent file sheets so a full set can be viewed quickly and easily simply by holding the sheet to a window or placing it on a lightbox. Medium-format slides can either be presented in individual black masks or pockets.

Black and white prints should ideally be 10x8in (25x20cm) and printed on glossy resin-coated paper with a neat white border around the edge to offset the image. Again, all relevant details should be typed on a sheet of paper and stuck to the back of each print.

Once you've assembled the pictures, type a covering letter explaining the nature of the submission. This should be kept short and to the point. A typical letter might read:

> Dear
> Please find enclosed a selection of 35mm colour transparencies which I would like you to consider for use in The Magazine at your normal rates.
>
> The subjects covered relate to various aspects of camping and caravanning and may be suitable for illustrating features or as 'fillers' on your letters page. If you feel any of the pictures will be suitable for publication, I have no objections to you holding them on file. However, should they fail to meet your current needs, I would appreciate it if you could return them in the SAE provided.
>
> Thank you for your time. I look forward to hearing from you soon.
>
> Yours sincerely,

Finally, place the letter and pictures between two sheets of stiff card and slide it into an envelope, remembering to enclose a stamped, self addressed envelope for the return. If you fail to do this, your pictures may be held on file for a few months then destroyed if you don't ask for them back and supply the postage required, as it would be too costly to return every 'on-spec' submission.

Ideally, the package should be sent by an insured method of posting. That way, if it never arrives, you can have the package traced by the postal company.

On no account should you:

* Send glass-mounted slides – they always break and can damage the slide as well as injuring the unlucky recipient.
* Wrap your slides in tissue paper or other silly packaging – it's unnecessary, the file sheet will provide suitable protection.
* Enclose loose stamps and ask the editor to re-use the envelope your pictures arrive in. It's time-consuming, fiddly and downright annoying.
* Seal the envelope with layers of tape or staples – both are unwieldy to undo and are unlikely to make a favourable impression.
* Enclose postcards or letters to acknowledge receipt of the pictures – the magazine will do this if the submission is being retained.

Once your submission has been left in the capable hands of the postal service, forget about it for a week or so. It's tempting to telephone the editor two days later to ask if the material will be used, but chances are if it has arrived, it may still be laying unopened, and if it has been opened, it's doubtful a decision will have been made – unless the pictures are totally unsuitable, in which case they'll be sent back by return of post.

What normally happens when pictures are submitted to a magazine is they are opened, looked at, and if there is the possibility any could be used, a note is usually sent out to acknowledge receipt and explain that the pictures are being held on file. Alternatively, the editor may pass them on to the picture editor or features editor for further consideration before a decision is made. If you don't hear anything after a week or ten days, telephone and enquire, but do not pester – if you're on the phone every five minutes, your pictures will be returned just to keep you quiet, no matter how good they are!

Adding words

A great way to increase the possibility of your pictures being used is by writing either detailed captions or some kind of commentary to go with them. In effect, this means you are supplying a completed article that could be used as it stands, rather than a selection of pictures. If you're thinking of sending in a set of pictures of different styles of front doors to a home improvement magazine, for example, write 500 words to go with them. The same applies to shots of churches throughout your vicinity, or a portfolio of pictures taken in a particular town or city.

Owing to the way in which magazines are put together, editors often find themselves needing to fill extra pages at the last minute because the sales team has taken a late advertisement booking and in order to fulfil it the issue size has to be increased by four pages. This means that additional editorial material is required. Having a selection of suitable 'features' on file solves this problem because they don't have to worry about generating any words – it's all there.

Colour slides should be presented to magazines in slide mounts or black masks. Not only does this look neat and professional, but it also makes viewing of the images much easier. Always ensure that a suitable caption accompanies each picture, either on the mount or on a separate sheet.

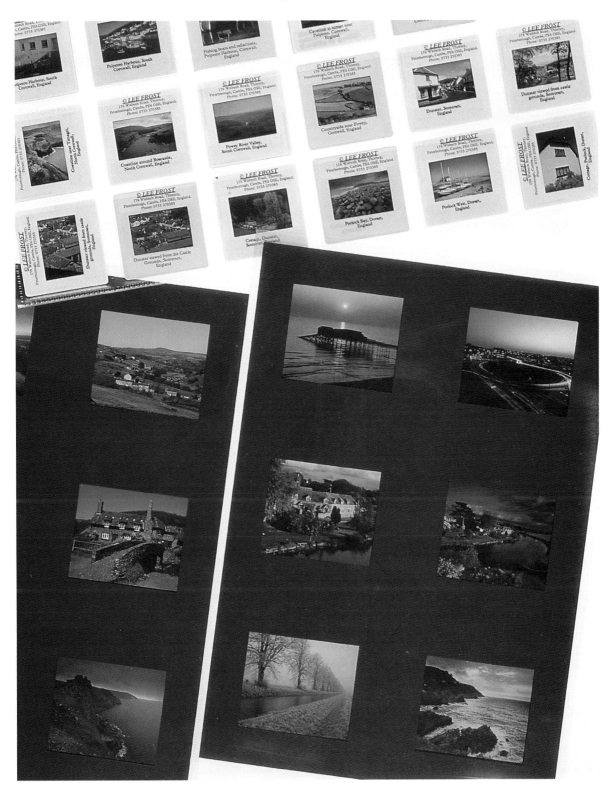

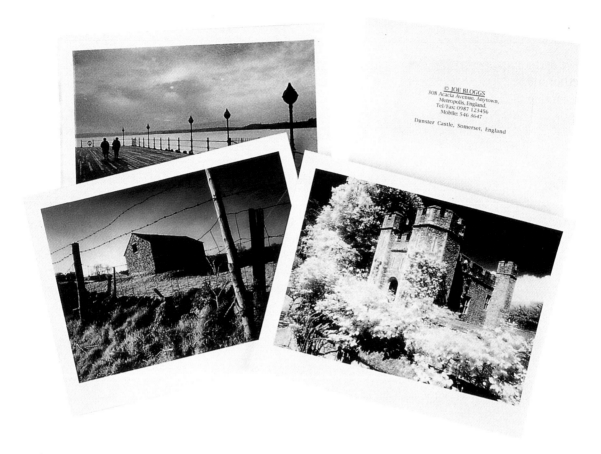

Obviously, you need to have some level of writing skill to succeed at this, but with care and time it shouldn't be beyond anyone to string together a few hundred interesting words on a subject you know something about.

Once you've had a words-and-pictures package published, it is also much easier to secure future sales because you are a known quantity, and editors will be far more inclined to listen to you. This, in turn, means you can discuss ideas for features to see if the editor is interested before committing time and money to them.

On assignment

The logical step from submitting pictures to a magazine on a speculative basis is to try to secure commissions. This approach is preferable as it

If you're submitting black and white pictures, most magazine editors prefer 10x8in (25x20cm) prints on glossy paper, with a neat white border and information on the back.

means you have guaranteed payment at the end, whereas submitting pictures to a magazine guarantees nothing unless you've received a specific, urgent request because an editor wants a picture you have.

How do you get an editor to commission you? Well, in my case I was fortunate to have worked as a journalist for several years before becoming a full-time freelancer, so by the time I took the plunge, I was known to many editors within the parent company.

For most freelancers, however, it's down to

hard work and perseverance. Making 'on-spec' submissions is a good starting point because it helps you and your work to become known. Once you've had some pictures published and gathered together a selection of tearsheets, you can then start touting your trade.

One approach is to suggest ideas for features or picture stories to the editors of magazines which you're already supplying. They won't necessarily be accepted, but at least you've shown a willingness to take on commissions, and eventually there may come a time when all the regular freelancers are fully booked and the editor needs to look elsewhere.

Another option is to put together a portfolio of pictures (prints and slides) plus tearsheets (see page 16) and make an appointment to show your work to the editor. Again, nothing is guaranteed, and magazines vary in their approach to portfolio viewing, but if you're good at what you do, you will find no editor will ignore you – more fool them if they do.

If you are commissioned, then you need to be on your toes because you really are 'only as good as your last job'. In other words, if you make a mess the first time, it will probably be your last. So you must make sure you have all the right equipment with you (take *everything* if you're unsure), that it's all in working order (do routine checks the night before and carry spare batteries), buying sufficient film stock (if you think you'll need 10 rolls, take 20), following any instructions supplied (get them in writing if necessary), and turn up in the right place at the right time (look at a road map and allow for delays).

You can never be too cautious on a commissioned job, especially in the early days, because if things are likely to go wrong they will. I always bracket exposures more than usual, even if it means covering some of the film costs myself, so that I'm guaranteed perfect results. I also check everything religiously, because in the heat of the moment it's easy to forget something and ruin a shot, or, heaven forbid, a complete shoot.

Saying that, I've still had my fair share of problems. I'll never forget the day I spent doing packshots in a studio with my camera set to the wrong flash synchronisation speed, so every frame was partially blacked-out by the shutter blades. Or the time I was shooting outdoors in bad weather and had to uprate my film two stops, forgot to push process it and everything came out two stops underexposed. Or the occasion when I spent an hour firing away with no film in my camera!

These things happen, you just have to do your best to get around them. In the cases just mentioned, I avoided embarrassment by realising what had gone wrong before it was too late and managed to re-shoot. The problems begin when you don't realise. However, the normal procedure on many magazines is to take the film away from you for processing, so often you don't see the results until after the editor has. That's a rather scary prospect, but you get used to it, and with every job your confidence grows. Honestly!

What they pay

Rates of pay in the magazine market vary enormously depending upon how many copies are sold, the overall quality of the product and the generosity of the editor. All magazine editors are given a picture budget for each issue, so it's up to them to stick to it. That may mean paying small sums to unknown freelance contributors and readers so they can afford to commission expensive professionals for specific assignments. Generally, magazines have a rate per page for use of pictures, and this is reduced proportionally as the size of the picture falls.

What you're actually selling is a once-off reproduction right for the image. So if the same picture is reproduced on the cover or contents page of the magazine, you should be paid more – usually half or as much again. This means you can also offer the same shot to non-competing markets, such as calendars and postcards.

Name: **WILLIAM CHEUNG**

William is editor of *Practical Photography*, the UK's biggest selling photographic magazine. Published monthly, it has an insatiable need for good quality pictures that illustrate all aspects of photographic technique, so there are many opportunities for regular freelance sales.

'The most fundamental thing to bear in mind is that the pictures submitted have a strong technique bent, so they can be used to illustrate a specific point, be it depth-of-field, creative use of shutter speeds, the rule-of-thirds, a polarizing filter and so on.

'Even better are before and after pictures. We have tremendous difficulty coming up with good comparison sets because most photographers never think to shoot them.

Practical Photography is Britain's biggest selling photographic magazine with an insatiable need for high quality pictures.

'All you need to do is compile a list, carry it around with you, then refer to it when you're out taking pictures. While shooting portraits you could do some with and without soft focus and warm-up filters, with and without fill-in flash or reflectors, the same shot at a wide and small aperture, and so on. With landscapes, things like the same scene from different viewpoints, in different light, or shot with different lenses are invaluable.

'The pictures need to be pictorially strong, of course. Anyone can shoot a comparison set in their back garden, but that doesn't mean it'll be interesting.

'Timing is important when you submit work to *Practical Photography*. There's no point sending us a set of winter shots in the winter – we need them by early autumn. Similarly, submit autumn pictures during the middle of summer, and travel or holiday pictures for a summer issue in early spring.

'Accessibility should also be considered. We don't mind publishing shots of exotic locations in travel features, or as examples of great photography, but in general technique features we like to keep subjects within the UK, so other readers don't feel it's out of their league.

'Once you've put together your submission, make sure every picture has your name, address and phone number (day or evening) on it. A brief caption mentioning where it was taken and the camera/lens/film used is also handy, but we can phone for other details. Captions can be written on small sticky labels then attached to slide mounts or the backs of prints.

'Ideally, slides should be placed in a transparent storage sheet so they can be viewed quickly and easily by lifting the sheet to a window – elaborate forms of mounting are more trouble than they're worth. The same goes for glass slide mounts, which always break in the post. Prints should be unmounted, glossy finish and ideally no bigger than 10x8in (25x20cm).

'Initially, send a batch of about 24 pictures so we can get an idea of the quality. We may then decide to keep some or all of them or request more. Our picture files are given a spring clean every six months, so be prepared for your work to be held that long. If you ever need it back, phone and we'll return it.

'No one will ever get rich supplying pictures to *Practical Photography,* but if you're prepared to make the effort, the rewards can be very welcome indeed.'

Here is an ideal example of the type of picture that could be sent to a photographic magazine: it clearly shows the use of an orange filter, perspective, colour and creating silhouettes.

Photographic magazines are always in need of good quality comparison pictures showing aspects of photographic technique, so remember to shoot the 'befores' as well as the 'afters' and you could find yourself making regular sales. This pair of pictures shows the same subject photographed with and without a polarizing filter.

Name: **DAVID TARN**

David's freelance career began when he started submitting landscape pictures to photographic magazines while still an amateur. Now, several years later, his work is published in a variety of different magazines, as well as on calendars and postcards.

This wintry landscape captured by David Tarn has been published several times, as a postcard, in calendars and in several magazines.

'My first picture was published in a photographic magazine after I entered it in a competition. Soon after, the editor telephoned me and said that if I had more work of the same standard he'd be interested in running a portfolio. I promptly submitted a set of pictures and they came straight back!

'Nevertheless, I was bitten by the idea of seeing my work in print, so I followed it up with further submissions and soon started selling pictures on a regular basis. I also started receiving requests from

magazines for pictures to illustrate features, and today my work appears in all the amateur photographic magazines – I have something published at least every month.

'I find it hard to understand why the editors and journalists on the photo titles have to actively seek pictures. To me it was always the first and most obvious outlet for my work, but for some reason most photographers tend to ignore it. Perhaps they think the magazines are over-subscribed?

'Once I'd sold a few pictures I started looking for other magazines that might be interested in my work. It was a simple case of looking through different titles. That's how I came across a magazine for walkers and ramblers, which is probably my

David's high quality shot of a waterfall was used as the main cover image of a popular outdoor magazine, and has also been published in several photographic magazines. David bought the red coat specifically so it could be used to add a splash of colour to such images. A little ingenuity can go a long way.

front of the camera and pose in the foreground of the scene!

'Because I shoot landscapes almost exclusively, I'm quite limited in the number of magazines I can supply. However, what I've found is that once your name is known it gets passed around. The publishers of the walking magazine also publish one on horses, and recently they called me for pictures of bridleways to illustrate a feature. Now, whenever I'm out shooting, I look for subjects that might be of interest to them, along with all the other magazines I supply. The more outlets you can serve with a single trip, the more cost effective it becomes.

'Another good way of finding outlets is to subscribe to one of the freelance newsletters. These usually have picture requests from magazines and I've sold lots of pictures through one newsletter in particular that I wouldn't have normally.

biggest outlet after the photo titles.

'Three of my pictures have been used as the main cover image, all of which I shot specifically. I even went to the trouble of buying a bright red outdoor jacket as I thought it would look really strong in the shots – it's been used twice on the cover so far. If necessary, I often wear the jacket myself, then once the shot is set up, I operate the self timer, dash in

'For example, a few months ago there was a request in the newsletter from a magazine called *Healthy Eating* for shots of seaweed. I only had three, but I sent them in and one was used across a spread. I've also had another shot in the magazine since, and the reproduction fees have more than paid for the subscription to the newsletter.'

SELLING TO NEWSPAPERS

PRESS PHOTOGRAPHY has always been surrounded by a certain aura and mystique. The idea of racing around in fast cars and stalking subjects with long lenses to grab exclusive pictures for the front page is glamorous stuff, and every year hundreds of new hopefuls join the throngs of photographers door-stepping the rich and famous.

When you look at the rewards on offer, it isn't difficult to see why this overcrowded area of photography holds appeal. The national daily newspapers are quite happy to pay large amounts of money for a single picture. Repeat sales at home and abroad can also boost the total sales revenue considerably.

Of course, not everyone in this game enjoys such profits or the glamorous lifestyle associated with press photography, but even on a smaller scale it's possible to sell pictures on a regular basis and have lots of fun at the same time.

Local newspapers

If you fancy trying your hand at news photography, a good place to start is the local newspaper. Virtually every town and city has at least one, and although most of the subjects covered tend to be rather mundane, it can provide useful experience.

It is best to begin by telephoning the picture editor about the freelance opportunities. In some areas, the newspaper will have sufficient staff photographers to cover just about everything, so only exclusive or off-beat shots will be of interest. On others, the newspaper may rely heavily on freelance 'stringers' who can be called upon at short notice to cover an event or story or supply routine shots to illustrate a feature. This could be anything from a local gardener who's just grown the world's biggest turnip, to photographing the

The key to success with news photography is arriving on the scene of dramatic events as quickly as possible, so you can take pictures before anyone else. Often, listening to your radio is all that's required, as news bulletins provide up-to-the-minute information on what's going on in the area. Once you have taken the pictures, get in touch with the newspapers immediately and let them know what you have.

scene of a major traffic accident.

The local newspaper in my area has six staff photographers, so freelance opportunities are few and far between. But there is some scope for photographers covering local sporting events on a Saturday – the busiest day of the week – and for supplying exclusive pictures. Recently, for example, a pop star collapsed while performing at a show in the city, and a local amateur was on hand to capture the moment. His picture made the front page because no staffers were present.

The key to success with local newspapers is to be aware of what's happening in your community so you can quickly discover whether anything newsworthy is about to happen and if you can turn it into a saleable story. Maybe there are secret plans for a celebrity to visit, or that a load of rubbish dumped locally is a potential death trap for unwary children playing on it.

It is your job as a freelance press photographer to seek out these stories and cover them. Anything

with human interest value, controversy, drama or intrigue is suitable fodder. But ideally, you need to cover things that the newspaper doesn't already know, otherwise you could find yourself rubbing shoulders with one of the staffers, in which case you're wasting your time.

During my time as a journalist on a photographic magazine, for example, a reader wrote to me explaining how he was driving along and came across a three-wheeled car that had burst into flames. The fire brigade were there, and the unfortunate owner, but no attempt was being made to douse the flames because the fire brigade had told the owner he would have to pay. He refused, so they let the car burn. The reader captured this on film, and sold the pictures to several newspapers, both local and national, making a handsome profit for just a few minutes' work.

This tale also highlights the importance of carrying a camera at all times, because you never

Shots of visiting celebrities are ideal for local newspapers, so make sure you are aware of forthcoming events in your area. This picture by Derek Gadd, an amateur photo-journalist, shows the well known TV presenter, Roy Hudd, reading to a group of children in a library.

Sports days, country fairs, and carnivals all provide rich pickings for the ambitious press photographer, and most local newspapers run picture stories on such events. You will be competing with staffers in most cases, but it's still worth attending then offering your work to the newspaper.

know when a potential story is about to happen. If you do not want to carry a full SLR kit around then a compact will do. Press pictures needn't be creative or particularly stunning, providing they tell a story. You should also shoot print film, not slide film, as it's easier and quicker to process. Ideally, keep your camera loaded with colour print film – ISO200 or 400 so it's fast enough in poor light. That way, the shots can be reproduced in colour or black and white.

National newspapers

Breaking into this arena can be very difficult, simply because there are so many photographers operating in it already. All the national newspapers have a large contingent of staff photographers who cover the big stories, and they are backed up by known freelancers who have already made the break.

Joining them is really a case of hard work and perseverence. If you have tearsheets from local newspapers and a good portfolio of news pictures, then it may be worth trying to show your work to the picture editors of a few newspapers, but don't hold your breath – they receive enquiries of this nature all the time, and are often just too busy to fit anything in.

If you are able to do this, the advice obtained will be invaluable. You may be told to go away and work on your portfolio, or if it already shows a high standard of work you may be given the odd job – if a story breaks in your area, for example, you could be asked to cover it as this is quicker and cheaper than sending a staffer.

If you don't fancy this approach, all you can

really do is take pictures of subjects that are currently in the news, send them in and hope you'll make sales.

Some photographers concentrate on local stories with national appeal and make a lot of money doing so. Serious crime or tragedy is always of interest to any nation, along with anything really off-beat, such as the old lady who defeated a gang of muggers with her handbag, or the man who painted his house to look like the national flag. The key is knowing what has national appeal and what doesn't – read the popular press regularly and you'll get a pretty good idea.

Alternatively, you could invest time and money travelling to cover newsworthy events. Big demonstrations, picket lines, political rallies and protests always generate interest from the press. The problem here is that you'll be working alongside established freelancers and staff photographers from the very newspapers you're hoping to supply, but if you get pictures that are better, there's no reason why they won't be used, or at least get your name noticed.

This can be a real uphill struggle, but if you're intent on making your name as a press photographer, you must look to these options.

Good quality sports pictures are always in demand on a national and local level, so if your action skills are keen, this is one area worth pursuing. Most newspapers don't have enough staff photographers to cover the large number of weekend sporting fixtures, so freelancers are often used as back-up. Once you have made a sale, the picture editor may be willing to let you use the newspaper's name to obtain a press pass to bigger events, or even offer the occasional commission.

Time factors

Time is always of the essence with press photography, so you need to act quickly. If you think you have a real exclusive, telephone the picture desk and see what they suggest. Most picture editors will tell you to deliver the unprocessed film and leave the rest to them. National newspapers may even offer to send a motorcycle courier out if it's that urgent.

For general interest pictures, however, you should have time to process the film yourself or drop it in at a one hour minilab. You can then either deliver the prints and negatives or post them. If you're shooting black and white, supply 10x8in (25x20cm) glossy prints. It's also a good

idea to supply any useful information with the goods, such as your name and telephone number, the names of any people in the pictures – if you were able to obtain them – what the pictures show and where they were taken.

Once the goods have been handed over, make yourself scarce. In the newspaper world there's always another deadline looming, so no one will take too kindly if you break into an elaborate tale

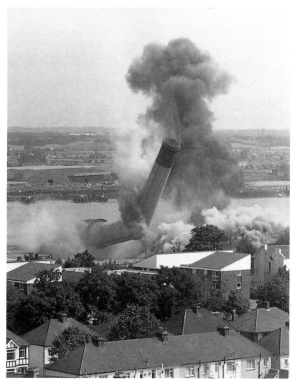

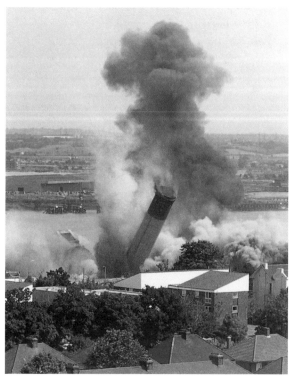

Capturing sequences of shots of dramatic events – in this case the demolition of a tower – will increase your chance of making a sale to both local and national newspapers. Also, the reproduction fee is likely to be higher simply because more than one picture will be used.

about how you took the pictures, the trouble you've gone to and so on. All the picture desk is interested in is the picture itself, so leave the staff to get on with their job and you'll gain respect for the future.

One final thing: before investing time and money trying to take pictures for local newspapers, check whether or not they actually pay reproduction fees. Many don't, as they consider the prestige of having your picture published to be a big enough reward in itself. Initially, you may be happy with this, as it will provide tearsheets for your portfolio, but if your intention is to make money, then you'll be wasting your time.

Name: **MIKE PETT**

Mike has a long career in press photography. Initially he started out as a staffer on London's Fleet Street, but since the 1960s has been running his own freelance press operation and sells his work to all the national daily newspapers.

'I tend to work in one of two ways: either I cover stories myself then sell the pictures on to the newspapers, or the newspapers commission me to do a specific job with a fixed fee.

Over the years, Mike Pett has established a chain of contacts which means little happens without him hearing about it. In many cases he is the first photographer on the scene, and this enables him to take highly newsworthy pictures. In this case, the aftermath of a lorry demolishing a house provided another sale to a national newspaper.

'Working on my own initiative is preferable because the financial rewards can be so much higher. Last year, for example, I heard that a ferry was in trouble off the coast early one morning, so I grabbed my gear, chartered a small fishing boat to take me out to sea, and got exclusive pictures of the lifeboat bringing in survivors. By the time other photographers arrived, the lifeboat was almost back at the harbour and the story was dead.

'The pictures I took were used in the national newspapers the same day. They were also syndicated worldwide by Associated Press, which handles some of my work, and are still selling today.

'The fee for such a shot varies depending on where it's used, but generally the tabloids pay more than the quality dailies and a single picture can easily generate a lot of money in repeat sales. My policy is I'll take what the newspaper offers, and I've never been disappointed yet. If a picture's worth having, they'll pay you what it's worth and be fair. Try to push it too far, though, and you'll upset them.

'The key to success in this game is being the first there, so your pictures are unique. Over the years I've established a network of contacts who telephone me day or night if a story's breaking, and I'm off immediately. Obviously, I have to keep them

sweet for their information, but it works in my favour and I'm happy to do so.

'Once I've got the shots, I'm straight on the telephone to the picture desks. If they're interested I go home, develop the film – I shoot either Fujicolor Super G 400 or Super G 800 – then drive up to the offices and drop the negatives off at all the newspapers. To give you an idea of the time scale, the shots of the lifeboat were taken around 7am, and the negatives were with the picture editors by midday.

'On a typical job I'll take a Canon EOS-1 body, with an EOS 600, plus 35–70mm, 35–105mm, 70–210mm and 300mm lenses. I also have a couple of weatherproof compacts, a monopod, a couple of clamps for the camera, a pair of flashguns and a mobile telephone. That little lot will cope with just about anything. '

Name: **THE DAILY MIRROR**

With a circulation of several million copies per day, the *Daily Mirror* is one of the UK's most popular tabloid newspapers, and has a voracious appetite for newsworthy pictures. The newspaper's assistant picture editor explained how freelancers with suitable material can see their work in print.

'We get a lot of telephone calls from photographers who think they might have pictures that could be used in the *Mirror* – readers mainly, who happened to have been in the right place at the right time with a camera and caught something dramatic, unusual or offbeat on film. Recently, for example, a photographer got in touch saying he had photographed ghosts in a window at a royal palace, so we biked the picture over. Actually, it was just the play of light on the glass, but it looked a little eery, and the shots were a little tongue-in-cheek, so we used them.

'If it sounds interesting, we will always ask to see it, and do our best to get the film in as soon as possible – usually by sending a courier to the photographer. It doesn't matter how far away they are, we will get hold of the film somehow and take it from there. When you look back at some of the most memorable news pictures of our time, a fair proportion have been taken by amateurs, not professionals, so we're always keen to see work.

'My advice to photographers interested in selling pictures to newspapers is always carry a camera – even if it's just a compact – keep your ears to the ground, and if anything interesting comes up, photograph it then telephone us. Don't worry about getting the film processed – we will do that in-house. I would also stress that ideally everything should be shot on colour negative film. Most national newspapers have a colour section now, so if the pictures are shot in colour we have the option to use them in colour or black and white.

'Another way to sell pictures to the press is by concentrating on your local area and acting as a sort of regional freelancer. This can work well for us because a local photographer is often able to get pictures immediately, whereas by the time we despatch someone to the location the story would be over – like a bank robbery in progress, that kind of thing.

'We have quite a few guys doing that. They telephone the picture desk every morning to see if any stories have broken close to them, or simply go out looking for suitable material, shoot it, then telephone to see if we're interested.

'Speed is the key here. With a daily newspaper, yesterday's news is no good, so if a photographer has something good we need to know about it straight away. Freelance news photography is a tough business that takes hard work and dedication, but if you're willing to give it everything you've got there is a lot of scope for getting work published.'

The *Daily Mirror* is one of Britain's biggest-selling national newspapers, with a daily circulation of several million.

CALENDARS AND POSTCARDS

DARTMOUTH

THIS AREA OF PUBLISHING has always been a popular target for freelancers, and still is. Every year millions of postcards and calendars are sold in every country in the western world, so the demand for new pictures is ongoing. At the same time, however, breaking into it can be desperately difficult as the photographic requirements are very specific, and only those who can satisfy them succeed.

It's very rare for a postcard publisher to launch

Here are three examples of pictures I have taken that have been published as successful postcards. As you can see, while pictures taken in bright, sunny conditions are a popular choice, more dramatic shots can sell if they depict scenery that suits such treatment.

Here is a typical calendar shot that's almost guaranteed to sell. Taken in perfect weather conditions, with a polarizing filter to deepen the blue sky and increase colour saturation, it shows an attractive subject, includes human interest, is well composed, and was shot on the 6x7cm format using Fujichrome Velvia slide film to give optimum image quality.

a new range of cards simply because they like a set of pictures that have been sent in. If a new range does appear, it's usually only after months of market research to assess the reaction of both the selling outlets and the buying public. While the images are occasionally supplied by one photographer to provide consistency in style, more often than not they are collected from a variety of different sources.

On a day-to-day basis, postcard publishing is far less active. The usual scenario is that when it is decided to update certain cards in a range, the picture editor finds suitable new images by sending out copies of the existing cards to a pool of regular contributors who may have suitable material on file, or the time to shoot those subjects specifically.

Calendar publishing is equally difficult. The vast majority of calendars are produced by a small band of companies who can be very choosy about which pictures they use. After all, a calendar needs only 12 images and lasts a whole year, so it's rare for the picture buyers to find themselves hunting around for suitable shots at the last

minute – they have been organized well in advance.

There are two main arms to this industry – general calendars which are sold to the public, and corporate calendars that are produced for specific companies who use them to promote their services. Within the corporate wing you also get some publishers producing standard calendars on to which company logos are added, and others who produce bespoke calendars containing images chosen by the client from a selection offered.

Once you've found favour with a publisher of either calendars or postcards, it's usually quite easy to make repeat sales. It's getting that initial foot in the door that can be tricky. I sent pictures out to every major postcard and calendar publisher in the country at least twice before anything was even kept on file for possible use, let alone guaranteed use, and in total it probably took two years before a single sale was made. After that it became easier, however, and before long I found that publishers were telephoning me with specific picture requests, or using something from every batch I submitted 'on-spec'.

Today, I make regular sales through major postcard and calendar publishers, and my work is also handled by a company that produces exclusive corporate calendars. The profits aren't amazingly high, but when you're freelance, every little helps.

Although you're better off trying to sell pictures to calendar and postcard publishers in your home country, there's no reason why sales couldn't be made overseas of international landmarks – in this case Italy's Leaning Tower of Pisa.

Some postcard publishers accept more creative images for cards aimed at the general public rather than the tourist crowds. Many people use attractive postcards to send notes to family and friends, for example, and want something other than a standard scenic. If you explore the postcard market in your area, you will probably find at least one 'mood' or 'atmosphere' range. Although less common, such images can be big sellers.

Give them what they want

Photographers often use the phrase 'picture postcard scene' to describe pictures containing bright blue sky, fluffy white clouds and twee subjects like thatched cottages, pleasant landscapes, sunny harbour views and beautiful sunsets. Why? Because traditionally that's exactly what postcards depict.

The vast majority of cards sold are bought by tourists on their annual summer holidays, so they want something that can be sent back to family and friends to show what a wonderful time they're having, or to keep as mementos for the family scrapbook.

The subjects depicted also tend to be the most popular ones. In a coastal town, for example, the beaches, harbour and local landmarks will be the biggest sellers because they sum up the place in the single shot, and anything remotely obscure is rejected out of hand.

To put the odds of success in your favour, you need to be shooting in ideal weather conditions. That means a clear, sunny day, preferably during early morning or late afternoon when the sun's on its descent and the light has lost the harshness of midday. Morning is a better time in many ways

as there will be less people and traffic around. You will probably have difficulty avoiding either, but keep it to a minimum as both immediately date a picture – clothing fashions, car designs and number plates are all indicators of when a shot was taken. Postcard publishers spend a lot of money producing their cards, so they like them to be as timeless as possible for a longer shelf life.

When you're composing a shot, try to include some foreground interest to give the scene depth and scale. If it's a harbour scene – use a boat; if it's a landscape – use a stream, gate, or wall. Postcard pictures should sum up a place as best they can, so often that means including as much information as possible – just about all the shots I have sold in this market were taken on a 28mm wide-angle lens. I also use a polarizing filter for just about everything, to saturate colours and deepen blue sky, plus an 81B or 81C warm-up to get rid of any blueness in the light.

In terms of film stock, 35mm slides are the norm, although medium-format is accepted by all and preferred by some. I always use Fuji Velvia, simply because it's so vibrant and sharp, but Fuji Provia 100, Kodachrome 25 and 64 and Ektachrome Elite 50 are also good choices.

Gardens and floral subjects – in this case a field of tulips –
are popular subjects for calendars, along with vintage cars,
glamour, sailing and others.

Remember – you need to make everything look
as idyllic as possible.

There are exceptions, of course. In hilly or
mountainous areas, where visitors go to enjoy
the breathtaking scenery, traditional blue sky
shots are sold alongside more dramatic, creative
images. They often depict stormy, bad weather
scenes because such conditions are part of the
area's character. Soft focus and grainy images are
also popular. The same applies with stylish towns
and cities, where many tourists want more than
the typical 'picture postcard scene'.

What you will find, unfortunately, is that many
of these cards are produced by individual
photographers. This is mainly because most of
the big postcard publishers are still stuck in a
time warp and refuse to take risks, leaving a
gaping hole in the market for others to fill (see
pages 112 – 19 for details of self publishing).

If you're at all unsure about the type of pictures
that will sell, study the postcards on sale
whenever you visit a new place. I always make
that my first priority, because existing cards help
you discover the most popular scenes and the
best time of day to shoot them. I also make a note
of any new postcard publishers I encounter, as
they could prove to be another useful outlet.

Calendar conscious

The picture requirements of the calendar market
are similar in many ways. Next year's range tends
to go on sale during late summer/early autumn,
and if you look through a selection, you'll see
that a fair proportion consist entirely of pictures
taken in bright, sunny weather and feature the
regulation blue sky with a smattering of fluffy
white clouds.

Using filters to make the most of a situation can improve a picture and make it more saleable in the calendar and postcard market. This hazy dusk scene was attractive in its own right, but by warming up the light with an orange 85B filter, it has much more appeal.

Of course, there are exceptions. About half the pictures I've sold to calendar publishers have been photographically far more interesting, such as landscapes shot in the golden light of early evening, or popular landmarks.

It all depends what the calendar is for. A local company that manufactures engineering parts will probably be happy with standard scenics, while a design agency will prefer something a little more creative and varied. The same general rule applies to calendars which are sold to the general public.

In terms of 'theme', many calendars are regional, covering a specific town, city or county, and have a restricted sales area, while others are national or even based around groups of things: cats, fine art or recipes. The skill is knowing what kind of shots to

send out, and that only comes from trial and error in the beginning.

Another benefit of calendars is they feature a wider variety of subjects than postcards. Landscapes and general scenic pictures take up probably 80 per cent of the market, but the remaining 20 per cent comprises shots of beautiful gardens, vintage cars, sport and action, flowers, people, wildlife, pets and still life.

To find out which subjects different publishers prefer, check books such as the *Freelance Photographer's Market Handbook* or *The Writers' & Artists' Yearbook* in the UK and similar publications in North America, Australia and New Zealand (see page 152). While you're out and about it's also a good idea to look at any calendars you see hanging in shops or offices and noting the name of the publisher.

Following up leads like this can be far more lucrative than submitting work to all the well-known companies, simply because that's what everyone does. My biggest client is a company mentioned to me by another photographer. Armed with the name, I found the telephone number, called to make an appointment, visited the offices with a portfolio of images, and they've been using my work ever since!

Whichever publisher you approach, you'll probably find that 35mm isn't acceptable. Medium-format, preferably 6x7cm, tends to be the industry standard these days due to the superior image quality it offers, while some only

ABOVE AND OPPOSITE: Some postcard and calendar publishers specialize in using creative black and white images, so if you work in this medium you could make sales.

accept large-format – especially those publishers dealing with subjects such as cars, gardens and flowers. At the size most calendar pictures are reproduced, large-format isn't really necessary, but if the company insists, you really have no option.

My choice of equipment for calendar shots is a Pentax 67 with 55mm wide-angle, 75mm shift, 105mm standard and 165mm telephoto lenses, although I use the 55mm most often for landscapes and the 75mm shift lens for buildings, as it allows me to correct converging verticals. Again, film stock is always Fuji Velvia as it offers astounding quality, and I rarely take a picture without a polarizer, warm-up or grey graduate. I also use a tripod exclusively, even in bright sunlight, as it makes composing the pictures far easier and removes any risk of camera shake.

Copyright

The normal deal struck with postcard and calendar publishers involves you agreeing to relinquish card or calendar rights for one or two years, maybe longer. Always check the copyright requirements before agreeing a sale. The more you have to give up, the more you should be paid as you're sacrificing future sales potential. Also, if you sell a picture yourself and the same shot is being held by a picture library, inform them so they don't sell it to another calendar publisher, in which case you're breaching copyright and all parties will be upset if they find out.

If you do sell a picture to a card or calendar publisher, remember that you can still offer that same picture for sale to a non-competing market, such as a magazine, book or poster publisher.

Name: **GRAHAM PEACOCK**

Graham started selling pictures as an amateur photographer to help pay his way through college, and is now well known as a supplier of work to calendar and postcard publishers. In the last five years he has illustrated almost 40 calendars, and 60 postcards.

'When I started submitting my pictures to publishers, I was very naive and didn't really know what they wanted, hence I didn't have much success. However, as time passed and I began studying the market more closely I got a much better idea of what was required, and my hit rate increased rapidly.

'Today, I make sales through two different routes.

Firstly, I've built up a relationship with a wide range of large calendar and postcard publishers who regularly supply me with "wants" lists of pictures. As I've now got a collection of some 25,000 pictures, I can usually satisfy their needs. If not, I'll go out and shoot specifically.

'The other approach, and the one which I prefer, is to go to businesses and try to sell them a complete calendar. This involves presenting a selection of images from which they can choose a set, going away and getting a mock calendar produced, then if they like it, I have it printed.

'This is a much more lucrative way of working because it means the calendars are illustrated exclusively with my work, and I can add on extra for all the other jobs involved. I also work in conjunction with a design agency who do all the design work for the calendars, and a printer, so once the client has agreed on the pictures, supplied text and said yes to the design, I take it from there and deliver the finished product.

'In a way I have the best of both worlds, because I can produce high-quality bespoke calendars which act as a superb promotional tool for my photography, and I have complete control over the way pictures are used, the quality of reproduction and printing, yet financially there's no risk involved because I'm working to a firm order. I tried publishing my own postcards, but it took so much work that in the end I decided it wasn't worth it.

'I tend to target big companies that have a use for photography, such as the water and electricity companies, tourist offices, national parks, universities, and so on. I'm working on 12 calendars at the moment, and have already produced 38.

Bright colours, a strong composition and bright, sunny weather are the three ingredients that make this shot by Graham Peacock a good bet for calendar use. Being on location at the right time is essential if you want to take the best possible pictures – Graham is often out and about before sunrise.

'The main reason why I've been successful is because I specialize in photographing the area where I live, and as there are few photographers doing it, I've cornered the market. I'm also well known for the type of pictures I take, so I'm always being approached to supply pictures.

'The type of shots I take mainly depend on the type of calendar being produced. Calendar publishers still work to the old cliché that sunshine sells, so that's what I give them: pictures taken in perfect weather conditions with bright blue sky. This often means getting up at 4am during summer, so I can capture scenes before they're flooded with people and cars, especially in town and city centres. However, corporate calendars tend to be much more creative as clients are buying them to use for self-promotion, so I also shoot a lot of sunrises and sunsets, misty scenes, and other more moody subjects.

'In terms of equipment, I have three systems – 35mm, 6x4.5cm and 5x4in. I use 35mm for the smaller calendars, but for a larger scale the quality isn't really good enough so I move up to medium-format, or large-format when the finished product is going to be big and optimum quality is required.

'To sum up, the key to success in this market is

The famous Tyne Bridge in northern England is a subject that features extensively in Graham's work, as it symbolizes his home town of Newcastle-upon-Tyne and is in great demand from the many clients that now purchase his calendars or calendar pictures.

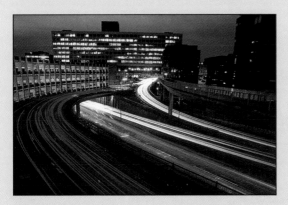

Night scenes showing traffic trails on busy roads are one of Graham's specialities. By concentrating on his local area, he has discovered all the best locations, and when to visit them to obtain the best possible results.

getting your work known so that publishers will use you, and also persevering. In the beginning I did a lot of knocking on doors and making telephone calls, often to no avail, but once I sold a few pictures and produced my first calendar it became much easier.

'I'm not quite at the stage yet where I'm making enough money to do this full-time, but by combining it with a part-time town planning job I'm gradually building up a large client base, and at some point in the near future I hope to take the plunge.'

Name: **JENNY CROSS**

Jenny is picture editor at one of the UK's biggest calendar publishers. Every year they publish almost 150 different calendars featuring landscapes, glamour, travel, vintage and classic cars and other subjects, and serve both the general market plus a wide range of corporate clients.

'There are three main areas to our business. Firstly, we're developing the retail side of things where calendars are produced for sale to the general public. Secondly, we produce a range of stock calendars which companies can have imprinted with their own logo and text, and thirdly, where orders are big enough, we offer a bespoke calendar service where individual companies can have an exclusive calendar produced.

'The way pictures are selected and used really depends on which of these three areas the calendar falls into. For the retail trade we put together a proposal which is then assessed; with stock calendars I choose the pictures to be used, and with bespoke calendars our sales representatives show portfolios of pictures to the client from which they make a selection. Also, the client occasionally supplies their own pictures, artwork and text, and we simply act as a manufacturer of the calendar.

'I have to look through an awful lot of pictures in my job – during the busiest period, which is the first few months of the year, I receive maybe three or four packages each day. Some are from regular contributors who I'm familiar with, but others are first time submissions. I also receive a lot of telephone calls from photographers who want to know if I'd be interested in seeing their work. Inevitably I say yes, because it's always worth looking at new pictures.

'The main thing I've discovered in doing this, is that most photographers tend to concentrate on a particular area of the country – maybe the region they live in. This is good in one respect because it means they're likely to have some nice shots of that area, but bad in another because it means I could only ever use one or two shots from a submission.

'Most of the scenic calendars we put together are nationwide, so they must have a good cross-

Every year, Lockwoods publish a glossy colour catalogue showing their full calendar range. This makes interesting viewing for the ambitious freelancer, as it gives a good idea of the type of pictures that are used and the subjects covered.

section of areas. Therefore, the photographers who we use most often are the ones who make the effort to travel around and build up a good collection of pictures from all over the country. Ideally, I like to use just two or three different photographers to illustrate a whole calendar, as it's much easier logistically. If I used 12 pictures from 12 photographers, I'd have to produce far more orders, and spend a lot more time clearing the pictures for copyright.

'So, my first tip for budding calendar photographers is get a wide selection of places on your files and you will stand a much better chance of selling your work. Last year I only used 13 different photographers to illustrate 14 different scenic calendars.

'My next tip is to make sure your work is of the highest standard. When I look at a set of pictures they go through several stages before acceptance. Firstly, they must not contain traffic, lots of tarmac, dustbins, road signs, graffiti, lots of people or rubbish. If they do, they're out. Secondly, they must be attractively composed, bright and colourful, and shot in clean, crisp light. That doesn't necessarily mean beautiful sunny weather – we use sunrise and sunset shots – but they must have lots of clarity.

'Finally, if those two stages are passed, I'll look at the slide through a loupe to check for sharpness. If it's anything other than pin-sharp, then it's rejected, even if I love the picture. In terms of format, we

This illustration shows a page from a typical Lockwoods calendar. One of my landscape pictures which was used in the calendar earned me a very welcome reproduction fee.

accept everything from 35mm up and we don't have preferences for specific films. That said, medium-format slides sell better than 35mm to corporate clients as they're easier to look at on a lightbox.

'As well as scenics, we also produce calendars featuring other subjects, such as glamour and vintage or classic cars. Actually, these areas are far more under-subscribed, so if anyone can produce top quality pictures, they stand a far higher chance of making sales. We use one photographer for all our car shots, for instance, simply because he's the only one we know with a good collection. Similarly, our glamour calendars are illustrated by only a few photographers who make a lot of money.

'If I decide to use a picture for a calendar, then I telephone the photographer and check for clearance – he may have already sold it to another calendar publisher, in which case we wouldn't be interested. This means having a good filing and record system is important on the photographer's part, otherwise problems occur.

'We then negotiate payment, which covers calendar rights for a specific calendar for that year. In other words, if we wish to use the same shot in another calendar, the photographer will receive further payment, and after one year he can offer the same shot to another calendar publisher. This is pretty much standard procedure.'

BOOK ILLUSTRATION

T HE BOOK PUBLISHING industry is undoubtedly one of the hardest for the freelance photographer to break into. This is mainly because the needs of individual publishers vary enormously, projects are often commissioned at least a year in advance, and the need for photographers to illustrate them isn't that great.

What usually happens is a photographer receives a commission to illustrate one book which sells very well, and their future is sealed, with follow-up projects on offer owing to the success of the first title. In the book industry, it isn't uncommon to find one photographer

A book proposal should be neatly presented and contain all the information the publisher will require to consider the idea and seek approval from colleagues.

illustrating five, ten, maybe more books, especially those that contain landscape, travel or garden shots. So he or she effectively has a monopoly on one of the subjects handled by the publisher, making it almost impossible for fresh talent to get a foot in the door.

To those photographers on the outside trying

to get in, this seems very unfair, but from the publisher's point of view it makes perfect sense. After all, why commission a complete unknown when there's a tried and tested photographer waiting in the wings? Would you?

In effect, what this means is you have to outsmart the established photographers if you want to find yourself in their enviable position, and that isn't easy because they already have a strong advantage.

Ideas sell

The easiest way to find your way into the book market is by coming up with ideas for books and submitting proposals to the publishing houses that might be interested in seeing them. Most photographers take the easy option by submitting a selection of photographs along with a letter saying please consider me for any book projects you may be undertaking in the near future. A good idea, but unlikely to win you any favours. Why? Because book publishers are generally inundated with photographers. What they don't have enough of is ideas, and that's where you come in.

If you would like to illustrate a book on the landscape of your home country, or a specific part of it, try to think of a way in which a book of those pictures could be different to similar books that are already on the market. Before submitting a proposal, it's also a good idea to study the market, just to make sure there aren't books already in print that are very similar. You can't predict what is about to be published, or be aware of ideas already waiting with publishers, but the more you know about the market, the better your chances.

One of the most impressive landscape books to be published in recent years is *England: The Four Seasons* by photographer Mike Busselle (see Pro-file, page 92). There are dozens of landscape books already in print, but Mike took a different approach by photographing the countryside throughout the year, returning to the same locations to show how seasonal changes transform their appearance. It worked. The book has been a huge success, he has since followed it up with a volume entitled *France: The Four Seasons*, and no doubt there will be others in the future.

This approach may not seem particularly original, but it is much more interesting than the run-of-the-mill book, which usually finds itself being sold in discount shops within months of publication. The same rules tend to apply in every other country throughout the world.

Of course, while fresh, innovative ideas are important, there's little point in coming up with book proposals that are too bizarre – there needs to be a market for the book when it comes off the printing press, and the more obscure it is, the smaller that market is likely to be.

Putting together a proposal

So, you've come up with a great idea for a book that you know will be a winner. The next stage is to sit down and look at that idea in more detail and get some thoughts on paper. Whenever I am putting together a book proposal, I always work through a set series of questions then write a suitable answer. These include:

* What the book is about – its basic theme and aims
* How those aims will be achieved
* Why there is a need for such a book in the market
* Who will buy it
* What will be in it – a brief contents breakdown, with notes on what will be in each section

In addition to this, I also comment on why I would be suitable to produce such a book, and provide some sample copy, such as the introduction or part of a chapter, so the publisher can get a much better feel for what it is all about.

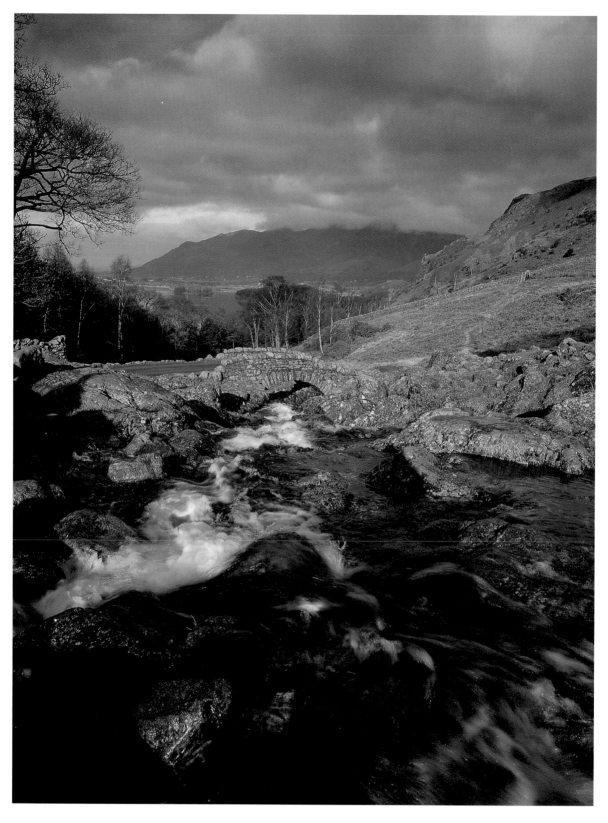

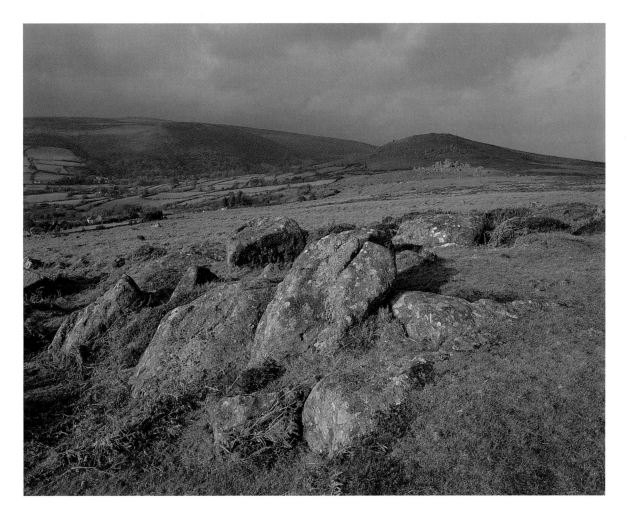

ABOVE AND OPPOSITE: Here are two examples of pictures which I produced for a book proposal. Only the highest quality material should be submitted; anything less will damage your chance of acceptance.

In terms of pictures, a submission of 10–20 colour slides, or black and white prints if that's the medium you will be using, is more than adequate. These pictures should have been taken with the book in mind, rather than a sample from your files, to show you have actually thought the idea through and done some groundwork - few publishers will commission an illustrated book on the strength of an idea alone if you are unknown.

If the pictures have been shot on the 35mm format, it might be worth having your submission duplicated up to 6x9cm, so the images are far easier to look at without the aid of a lightbox. Presenting them in individual black card masks will also put a professional touch to your submission. Remember - it has to impress without you being around to back it up.

With all this together, produce a brief covering letter explaining what the submission is about, and send it to the editorial department of the publishers you think might be interested in pursuing the idea further. You could make a phone call to determine the name of the publisher who will see your work, but most simply ask you to address it to the editorial department. It will then be looked at and a decision made. Details of

book publishers can be found in trade directories and professional handbooks; see page 152 for more information on these titles.

If your initial approach is rejected, don't lose heart – it happens to us all, often on many occasions. This doesn't necessarily mean the idea for the book has no commercial value, just that the publisher you approached isn't interested in adding it to their list. So, try the next name on your list and take it from there. If it's repeatedly rejected then you can assume that it's unlikely anyone will accept it. Unfortunately, publishers rarely give reasons for this, so you're left pretty much in the dark. You could modify the idea and try again, but usually you are better off working on something completely new than going through the procedure again.

It can take years before you come close to being accepted – many photographers never even get that far – but remember that once you have produced one successful book, it's much easier to get commissions for others, so your hard work won't necessarily be in vain.

Ideas for books needn't always be for subjects in your home country. I have made two visits to the beautiful 'White Towns' of southern Spain, for example, in order to take pictures for a book proposal on that subject.

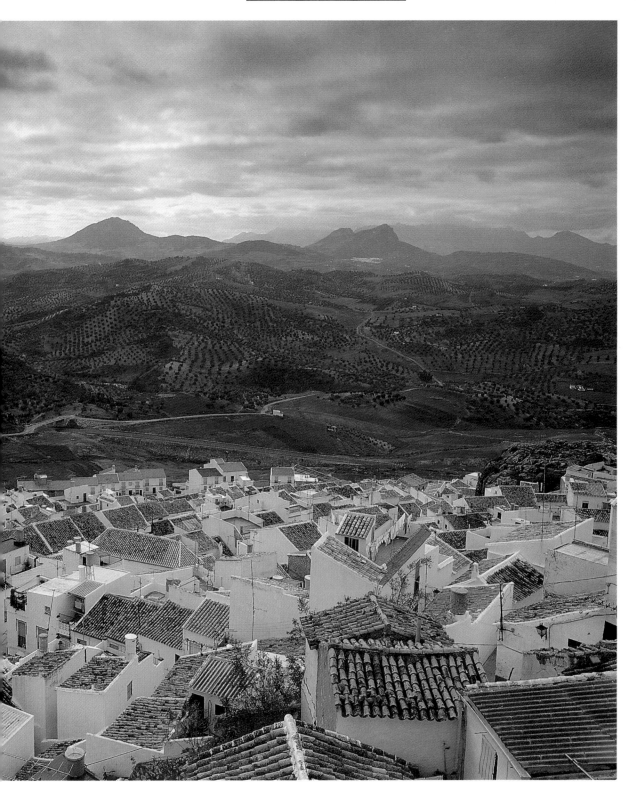

Name: **MIKE BUSSELLE**

Mike is one of Britain's most successful landscape and travel photographers. His first book, on photography, sold over 500,000 copies worldwide, and since then he has written and illustrated a total of 34 books on wine, travel and photography.

'If you want to get a book published these days and you don't have a track record to rely on, you really have to work hard and push publishers along – I still have to do that today. I have been trying to get a book off the ground for the last year on the villages of Spain, but I haven't been successful so far.

OPPOSITE: This stunning field of poppies captured in Spain is a typical example of the type of pictures Mike produces for his books.

'The main problem is that publishers are very reluctant to produce new titles, simply because there isn't much money to be made from them. In the past there were far less books available, so new titles sold in much bigger quantities, but today you are lucky to sell 10,000 copies, unless you are well-known and the book sells because of the name on the cover.

Here are just three of the 34 books Mike Busselle has produced over the years, all of them featuring his beautiful landscape pictures and all of them proving to be highly successful.

'A book only becomes financially viable if it sells 6–7,000 copies in the country of its origin, plus another 2–3,000 as an overseas edition and perhaps another 2–3,000 as a softback edition later on. So you can see that the margins are very narrow, and a book can easily sell at a loss.

'Most of the books I've written and illustrated started life as my own ideas which I presented to a publisher. Coming up with marketable ideas involves striking a happy compromise between avoiding clichés but not being too unusual. The view is if a book hasn't been done before, that's probably because it wouldn't sell, so I usually find that ideas are accepted when they're similar to previous publications, but offer something different.

'The main thing to remember is that a new book is always different because the pictures are different. So even though the theme may be similar to other titles already in existence, the pictures won't be and that becomes the selling point. Also, many books tend to be spin-offs from something else. My book, *England: The Four Seasons*, was partly illustrated with pictures that had been taken for other books but not used, so it was cheaper to produce. If the publishers had to pay me a huge advance to produce the thing from scratch, it would never have happened. That's why you often find the same names appearing time after time.

'When I come up with an idea for a book, I prepare a fairly elaborate proposal which outlines the content, theme and approach, but also gives detailed information about specifics. For a book on landscapes, for example, I would supply a detailed list of the locations to be included – with the book on Spain I listed around 500 villages that would be included in the text or illustrations. If the book is commissioned, this list may change quite dramatically, but it makes a good starting point, and gives the publisher a clear idea of my intentions.

'When an idea is submitted to a commissioning editor at a publishing house, it is discussed with the other editors at regular meetings. This discussion can lead to the acceptance or rejection of a book, so the more detail the editor has to talk about, the more confident they will feel about presenting it – and the more seriously it will be taken. For this reason, I even go to the lengths of making things up a little, just to pad out the proposal.

'Of course, the thing that's going to sell the book – and the idea – more than anything is the quality of the pictures, so you should never compromise this. I always go out and shoot images for a proposal that I intend using in the book itself. But send them sparingly. I usually submit no more than 20–24 colour slides or prints, but they are all top quality shots. If you send large numbers, what usually happens is the impact of the best is reduced by weaker images, so I keep the numbers down. Slides are usually submitted in black card masks, so they look impressive, and prints in a neat portfolio book.

'At the moment I'm finding it quite difficult to get new projects off the ground because publishers are more interested in titles that can be produced quickly and cheaply, which doesn't really interest me. Some photographers are interested – they will happily spend an intensive two weeks travelling around taking pictures for a book and sleeping in the back of their car to keep costs down, but the results are never as good as if you can spend more time on a project.

'The problem is the advance you receive to produce a book is rarely big enough to cover your costs. A trip overseas costs a lot of money, so if you find that the weather is bad when you arrive you will either have to go ahead anyway and take pictures in less than ideal conditions, or go home and fund another trip yourself at a later date. As soon as you get into this situation, you end up working to a loss. Remember – as well as paying for your costs while you are away taking pictures, you are also losing money that could have been earned if you were still at home. The sad thing is, most publishers don't want to know about this – once a contract is drawn up, that's it.

Planning a shooting timetable is essential when producing a book, as you need to complete all the illustrations within the alloted time and as cheaply as possible. Mike's usual approach is to make several long trips, and visit different areas during each.

'The way things stand in the publishing industry, there's absolutely no way I could make a living from producing books – and I've done more than 30. It just doesn't pay enough. In fact, I would say that every book I produce now is done so at a loss to me financially. But the way I see it is I can make a lot more money from those pictures once the book is finished by selling them through my stock library – Tony Stone – and my own picture library which I run from home. One picture sold through a stock library paid me more than the whole book did.

'This makes it financially viable for me to carry on illustrating books, which is fortunate because I enjoy the process immensely.'

WEDDINGS AND PORTRAITURE

WEDDING AND PORTRAIT photography is perhaps the most common and popular area of commercial photography accessible to part-time freelancers. That's mainly because it can be practised during evenings and weekends, which means you can minimise the financial risks by keeping your day job. If this sideline begins to flourish, you'll then be in the privileged position of being able to decide if you want to take the plunge and pursue it as a full-time career.

Most photographers who undertake portraiture and wedding photography usually fall into it by accident. Having become known among family, friends and colleagues as a budding enthusiast, it's common to be approached at some point and be asked to shoot an engagement portrait, a family sitting, or a whole wedding. Word then gets passed around, and before they know it, their services are in regular demand and requests start coming in from friends of friends.

Perhaps you're in that situation now, and undecided about whether to take things a step or two further? If so, what you need to bear in mind is that taking a few wedding snaps for your cousin, or photographing the neighbour's baby, is a far cry from dealing with complete strangers.

For a start, the pressure to do a good job is so much greater because you're no longer doing your subjects a favour, but offering a professional service that they will be paying for. As a result, they expect you to know exactly what you're doing, be confident of your abilities, and able to come up with the goods no matter what.

This is particularly important with weddings. If disaster strikes during a studio portrait session you can always eat humble pie and invite your subjects back for a free sitting. But if you mess up a wedding shoot, you could face legal action as well as a ruined reputation.

I know one photographer who was preparing to cover a huge wedding between two large families, when at one point the bride's mother politely told him that if he did a good job he would never have to work again. The trouble is, immediately afterwards, the bride's father added that if he did a bad job he wouldn't be capable of working again!

Still interested? Then you need to look at the implications of setting up a wedding and portrait business, whether it's on a part-time or full-time basis.

Learning the ropes

If you fancy setting up as a wedding photographer, but don't have any practical experience, there are a number of avenues worth exploring.

The easiest way is to offer your services free to

Successful wedding photography today involves more than simply posing a family group against the church entrance. The traditional pictures are still in great demand, but anything extra you can offer will not only enhance your reputation, but also increase your profit-making potential when friends and relatives of the couple order reprints.

In recent years, commercial portrait photography has undergone a revolution, and today more creative techniques are in demand – particularly among younger people.

LEFT: This pastel colour portrait was shot in the client's home using windowlight on an overcast day to provide soft, flattering illumination. Film stock was 35mm Scotch chrome 1000, and soft focus and warm-up filters were used to add mood.

BELOW: Another windowlight portrait, this time in black and white. At the request of the subject, the shot was printed quite dark and with a ragged border. Film stock was 35mm Fuji Neopan 1600, and the portrait was printed on Ilford Multigrade FB paper.

family, friends and colleagues, so you practise the skills and techniques involved. Obviously, this would be a foolhardy thing to do if you were in any way unsure of your abilities, but the very fact that you are thinking of operating as a professional should be a strong enough sign that you are capable, and are unlikely to ruin someone's most important day.

By following this route, you'll quickly get a feel for what professional wedding photography involves - not only from the photographic aspect, but in terms of people management, patience and self-control.

If that idea doesn't appeal, how about offering to assist a local wedding photographer, so you can watch an experienced professional at work? This is common in all areas of photography, and the very way many of today's top photographers learned their trade.

After a while, the photographer for whom you're working may be able to offer you a wedding to shoot alone – another common practice in the profession when business is booming – so you have the chance to obtain real 'hands-on' experience.

Once you've set up as a part-time wedding photographer, it's also a good idea to join a professional body which offers seminars and courses to teach members the art of successful wedding photography. Alternatively, you could learn by enrolling on a home study course and teaching yourself professional techniques with the help of expert tutors.

One of the most popular courses is with the New York Institute of Photography. Each student is supplied with cassette tapes, booklets and videos of professionals at work which teaches them everything from lighting techniques to business management, such as knowing what to charge, how to maximise your earning potential, self promotion and advertising.

Students are also encouraged to complete projects at every stage, and submit a set of prints plus written work to make sure they understand what they're being taught. The course tutors then prepare a 15-20 minute taped critique of the work.

Where to shoot

If your main interest is wedding photography, all you need to do is to put together a suitable camera system and you're ready to begin, simply because the location is dictated for you. With portraiture, however, you must decide how you want to approach it.

In the beginning, it is not necessary to hire, lease or buy your own studio space. A much better option is to offer a mobile portrait service, where you set up the lights in your subject's home rather than inviting them to a studio. If you do this, you don't even need a background system, as you can use the home setting for that purpose.

Working outdoors is also a good idea, not only because the lighting is free, but because you can produce more natural-looking portraits. Again, the client's garden may suffice as a suitable location, but if not there are suitable settings close by, such as a park or public garden. It's also worth looking for other more adventurous settings while you're out and about, such as an attractive five-bar gate to a field, a lush meadow, a crusty old barn, a fallen tree and so on.

If the time comes when you need a studio, then hire one for as long as you need. If you look in the telephone book, you should find at least one in your home town or city. Once the business starts to develop you can then think about a more permanent arrangement.

If all else fails, converting your own front room into a studio for the occasional shoot will be more than acceptable. Many photographers also convert their garage or loft into studio space. Providing it's suitably equipped, clean and warm, anywhere will do. If you're unsure, simply look at it from a stranger's point of view and ask yourself if you would feel relaxed and comfortable there.

Selling yourself

With both wedding and portrait photography, some form of advertising in your local area is almost essential to encourage custom. This can take various forms.

If you're on a tight budget, place business cards and sample prints with local bridal shops so they can be shown to customers. Placing your business card in the windows or noticeboards of other stores is also worth doing. Local newspapers should be considered - especially if they have occasional 'wedding specials' highlighting services on offer - and if possible, attend any bridal promotions in the area where you can get to meet prospective clients and introduce them to your work.

Finally, the business telephone directory is a must if you want your name to be seen by as many

people as possible, as this tends to be the first place many people look when they need a photographer. Over a period of time you will probably find that most of your bookings come from word of mouth – at least they should if you do a good job – so the advertising can be scaled down. Until then, however, it's worth investing a little money to get your business off the ground.

What to offer

Once you receive your first telephone enquiry, you must be ready with a plan of action. First, take their details, find out what it is they want and arrange a meeting. Offer to visit them, rather than asking them to visit you.

Naturally, any prospective client will want to see your work, so a portfolio of pictures is essential. For portraiture, you need to be able to show a variety of styles, from traditional head and shoulders to full length, group shots and more creative images such as sepia-toned black and white and grainy colour, or portraits that have been lit in an imaginative way.

For weddings, a complete album of pictures will serve the same purpose, along with perhaps a selection of alternative shots such as reportage-style candids in black and white. Couples today tend to want more than the usual set of family wedding pictures, so if you can offer something special you'll gain kudos.

By showing prospective clients your 'book' they can then go away and think about it in more detail and decide what they want. Being able to supply a price list for the basic job, reprints, albums and associated services is also a good idea, rather than appearing to pluck any figure out of the air when the conversation turns to money.

If you are commissioned to shoot a wedding, the next stage is to establish the date, time and where it will take place, along with the details of the reception venue. After that, check out both locations if you're unfamiliar with them, so you can establish an idea of the layout and where the various pictures can be taken.

Equally important is knowing where you can shoot in the event of rain. If there isn't suitable shelter, a local hotel or country house should be considered – conservatories and palm houses make ideal locations.

What to charge

Weddings normally have a standard price based on a fixed number of 8x6in (20x15cm) or10x8in (25x20 cm) colour prints in a good quality album. You could give prices for 20, 30, 40 and 50 shots, what it will cost for reprints, additional costs for more expensive albums and so on. If you're unsure, obtain a price list from a wedding studio.

You also need to source a good quality professional processing laboratory in the area that is used by other wedding photographers. Usually the films shot on the day are processed, then either proof prints are made, from which the now-married couple choose the final set, or all the shots are printed up to the final size and the selection is made from there. Portraits can be priced in a similar way so potential customers know what it will cost for the different types of shot offered.

To attract business initially, you could offer a special deal. Many wedding photographers offer their customers a free engagement portrait, for example – a good idea as it also helps break the ice between photographer and customer before the big day. Similarly, a popular ploy among portraitists is to offer a free sitting and charge only for the print – with no obligation to buy if the customer doesn't like the shots. This means risking time and money, but if you're confident of your abilities, you should be confident that you'll make a sale.

Finally, when you send out the wedding album or portraits, make sure a selection of business cards and price lists are included so satisfied customers can pass on your details to their family, friends and colleagues.

GOT THE GEAR?

Having the right tools for the job is paramount in this area of photography; not only because you need certain pieces of equipment to carry out the task in hand, but also because the general public expect certain things from you.

To begin with, medium-format camera equipment is used as standard by today's professional wedding and portrait photographers. 35mm is fine for informal grab shots at receptions, or for more creative types of portraiture – grainy, soft focus images and black and white, for instance – but for everything else you should really be using medium-format.

If you don't have the equipment already, there are inexpensive ways of kitting yourself out. A secondhand Mamiya C220 or C330 TLR (twin lens reflex) camera will be fine in the beginning. Either model can be bought cheaply on the secondhand market, and both offer the benefit of interchangeable lenses – the only TLRs to do so. Alternatively, if you want something more current, a 6x4.5cm camera from Bronica, Mamiya or Pentax

will do the trick – again, models can be sourced at good prices secondhand, and they give 15 shots per roll on 120 rollfilm, so they're economical to use. In terms of lenses, all you really need is a standard for group shots and a short telephoto for head shots. For wedding photography you should also add to your list a flashgun that can be used for indoor shots or fill-in outside – most professionals use Metz hammerhead guns – plus a hand-held lightmeter for ensuring accurate exposures. A sturdy tripod is also essential, plus two or three folding reflectors to help you keep shadows under control outdoors in bright sunlight, or to shade your subjects in harsh conditions.

For portraiture, you can use the same gear, but some lighting equipment will also be necessary for studio work. To begin with, this need only comprise two flash heads and stands, a softbox or brolly for each flash unit (softboxes produce more attractive light), plus a flashmeter.

In terms of backgrounds, you have various options. Manufacturers now produce a wide range of canvas backgrounds in a spring-loaded frame – like the reflectors – or loose canvas sheets that can be hung over a support or fixed to a wall. Many different colours, patterns and textures are available, and they are incredibly versatile. The main alternative is to buy a tubular steel frame from which paper rolls can be hung, or if you have a permanent studio set-up, fixings can be placed on the wall to hold paper rolls in place.

Film stock is almost exclusively professional colour print stock – Kodak Vericolour, Ektacolor Gold and Fuji NSP are popular choices.

Name: **NIGEL HARPER**

One photographer who took the bold step into full-time wedding and portraiture is Nigel Harper. In 1988, after years of entering photographic competitions and submitting work to photographic magazines, he decided to quit his job and become a full-time professional portrait photographer. Today, he has a thriving business, and in the last three years has scooped a dozen Fuji Professional Awards for his work.

'I was having a mid-life crisis, I suppose. I was bored with my career, fancied a change, and just decided to go for it. I'd done quite a lot of portraiture as an amateur, so I had a good portfolio to show prospective clients, but I'd never shot a single wedding in my life!

'To get around this, I hired a couple and photographed a mock wedding one Sunday afternoon so I could produce a sample album. I then placed an advertisement in the business phone directory and local newspaper and managed to secure a few commissions on the strength of those pictures. After that it just built up.

'I'm completely self taught. Right from the start, I decided I wasn't going to work with another wedding photographer because I wanted to develop my own style and be able to produce something other than the clichéd pictures you see so often. I felt this would help me carve my own niche in what is already a very competitive field. This approach certainly made the first wedding a little fraught, because I went into it cold, but I have no real regrets because now I feel I have a very distinctive style, and when you learn from someone else, it's almost impossible not to copy them.

'When I receive an enquiry from a couple, I first arrange to see them and discuss what they want, get details of the wedding and work out a price. If they employ me I then study the location of the wedding and reception. Usually one or the other will be all right to use in the event of rain – something you need to be aware of.

'On the day, my pictures are taken using a Bronica ETRSi medium-format camera, plus 50mm, 75mm and 150mm lenses. Fill-in flash is often used to brighten up shots, or a Lastolite reflector. In the car I keep a full back-up kit of cameras and lenses so I can switch over if something fails to work. So far that has never happened, but I still like to be covered – there's always a first time.

'Using the equipment and being able to take a correctly exposed picture should be second nature. If it isn't, forget about weddings. The key to success is getting on with people. Sometimes things become fraught, but you need to keep a level head, be Mr Nice Guy, and at the same time be able to direct everyone. If you're worrying about your camera that won't happen.

'By comparison, portraiture is a much easier

discipline. When I started out, I photographed everything either outdoors in natural settings such as gardens or parks, or in the client's home. I had a portable Lastolite background, plus a couple of studio flash heads, which was all I needed. Often I'd also make the most of the home setting, posing my subjects against a wall, window or fireplace. These days I use my converted garage for studio portraits, which is equipped with Elinchrom 250 flash units and softboxes.

'For self-promotion I have a colour card with pictures on the front and text on the back detailing my services. I send out copies with every enquiry, quote, album or set of reprints. I also have an advertisement in the phone directory still, but that's about it.

'So far things are going well. Last year I covered 60 weddings, and I recently calculated that about 75 per cent of bookings are through recommendations from satisfied customers – that's how it tends to work in this business.'

Here are a few examples of the type of portraits and wedding pictures that have helped Nigel establish a successful business and win a range of major professional awards. As you can see, they demonstrate a little more creativity and imagination than the standard family group shots. All were taken using a Bronica ETRS-i medium-format camera on professional colour print film stock.

COMMERCIAL AND INDUSTRIAL PHOTOGRAPHY

Creativity and technical skills are essential if you want to succeed as a commercial photographer, as you need to be able to tackle each commission with confidence. The motorcycle crash helmet in this shot was said to be 'as hard as nails', so to convey that the photographer gave the impression that nails were raining down on it by sticking them to a perspex sheet which was used in the background. This idea, coupled with careful lighting, has turned what could have been a mundane image into an excellent example of creative photography.

I F YOU LIKE the idea of taking on commissioned jobs that have guaranteed payment at the end, rather than submitting pictures 'on spec' to publishers or shooting stock, then you could advertise your services under the commercial and industrial banner.

What does this entail, exactly? Well, more or less anything really. Commercial and industrial photographers tend to work both indoors and out, photographing a wide range of subjects. One day you could be asked to shoot a new piece of machinery in a local factory, the next, a range of spectacles for a catalogue, or the opening of a new superstore.

For this reason, you really must be confident of your own abilities. You need to be adept at working with all kinds of light sources, be it natural daylight, flash, tungsten, or the complicated mixtures of artificial lighting often found inside buildings. Dealing with people who know little or nothing about photography, being able to follow a brief, complete a job on time and make the most mundane objects look wonderful are also prerequisites. If you lack any of these

skills then you could find yourself taking jobs on that are out of your depth and making a mess of them, or turning down work for fear that you won't be able to manage it. Either way, it's unlikely the client or would-be client will ever approach you again, which isn't much good when you're just trying to get established.

The same applies with equipment. You need a full 35mm and medium-format kit before you start, and access to large-format for the occasions when it may be requested. A studio lighting kit comprising at least three heads, stands, brollies and softboxes will also be required for interiors, portraits and packshots.

Any specialist items, such as fast lenses, expensive shift lenses, extra lights and so on can usually be hired if you live in a big town or city, but you need to check for such availability and if it doesn't exist consider your options, such as

Use of props and interesting locations is a key to successful commercial photography. For this promotional shot of products, the photographer used a window setting in an old house to add a rustic feel.

buying, leasing or loaning from a fellow photographer.

Processing laboratories also need to be considered as you could find yourself requiring a wide variety of services, from rushed processing, clip testing and proof printing, to multiple printing, big enlargements, framing, mounting, duplicating and so on. Again, most towns and cities have at least one professional establishment offering such services. If in doubt, ask a local photographer.

Detailed, technical shots of machinery parts may not make the most interesting subject, but they are just one of the many things you may encounter during your career as a commercial and industrial photographer.

Finding work

To find work in this market you must make your existence known to local businesses. That means advertising your services as widely as possible, at least until you have a substantial client base, commissions are offered through recommendations and your name is known in the area.

There are various ways to promote yourself. If you're working on a tight budget initially, place advertisements in shop windows or notice-boards, advertise in your local newspaper, plus any business journals and free news sheets. It's also a good idea to buy space in the business telephone directory for your area. A small display advertisement containing the company name, a logo perhaps, plus your address and phone number is quite costly, but it's money well spent as that is where the vast majority of people look when they need a photographer. It's also worth spending the extra on a display advertisement, rather than just two or three lines of standard type, as it will stand out on the page and give a better impression.

Another approach is to have a colour leaflet or card printed giving your name and telephone number, plus a selection of pictures showing a range of subjects, techniques and styles. A double-sided 8x6inch or A5 leaflet printed on glossy paper stock or card costs less than you'd imagine for a run of about 500-1000, but it looks very impressive. You can then mail out a copy to every design and advertising agency in the area, architects' offices, dentist surgeries, hair salons, bars, restaurants, and any other business you can think of that may need a photographer from time to time. If you only get one job as a result of this campaign, you will have covered your costs.

It is also a good idea to put together a portfolio of work that you can show prospective clients. Many businesses will commission you on the strength of a telephone conversation – especially if your name has been passed on by someone else. However, design and advertising agencies and many bigger companies will need visual evidence of your talents before committing themselves, so you must be able to offer that.

A typical portfolio should comprise a mixture of colour transparencies, prints and tearsheets showing examples of how your work has been used – pages from brochures, magazines, catalogues, leaflets and so on are ideal (see pages 14-19 for more details).

Arranging a job

As well as promoting yourself, you also need to be adept at dealing with people and putting across a professional image when they make contact.

People are a common subject for commercial photographers to have to deal with, so make sure your portrait skills are well honed.

Your first communication will probably occur by telephone, so get into the habit of answering the phone in a professional manner. Instead of the usual response of 'Hello', answer with your name, or the company name, and sound confident and businesslike.

Avoid letting your children or anyone else answer the telephone during working hours. Most business people will probably assume you have your own studio or office, so if a child answers, it gives a bad impression. Problems can be avoided here by using an answerphone, so if you can't take the call a message will be left. It's also worthwhile investing in a mobile phone so you can always be contacted when you're away from home or travelling.

When someone does telephone, make sure you ask for all the relevant details so you know exactly what you're taking on - the more you know at this stage, the better. With small jobs a phone call may be all that's required before you get on with it, but for bigger commissions that involve photographing people, places or objects on location, you should really make an appointment to see the person you're dealing with and get a better feel for the job.

You may be asked to offer a price over the telephone. This is always difficult as you can never be completely sure how long it will take, unless it's just a routine job that you've done before, so if you have any doubts, suggest that you get back to them later, or ask to see exactly what you'll be photographing. Never agree a price without thinking it through carefully, as you could find yourself losing money if you make an error of judgement.

When you actually attend the shoot, be professional and polite to everyone you encounter and always give the impression you're in control. Inside you may be nervous, but this must be disguised, otherwise you'll worry everyone else and they'll lose confidence in you straight away.

That means having all the right equipment with you, arriving on time, and not asking questions every five minutes because you haven't been listening. If you're shooting in a work location, you must respect the fact that other people there are doing a job too, and try to minimize any inconvenience caused. Once a shot has been set up, get on with it. If you're being accompanied by someone, forget about them and do your job. Don't be asking them to peer through the viewfinder every five minutes to check the composition, or that you've included what they wanted. This should be second nature if you've listened to them initially.

Finally, when a job is completed, have the film processed straight away and deliver the images

to your client, either by hand, by courier or by post. Remove any bad shots, pack everything neatly, include any instructions that are relevant, along with a compliments slip, a business card and any promotional cards for future reference, and make a follow-up phone call a few days later to check everything is acceptable.

The art of commercial photography isn't just being able to take good quality photographs, but being professional, efficient and courteous in everything you do, so that people feel confident of your abilities, comfortable in your presence, and willing to give you work in the future.

What to charge

This can be the most difficult aspect of commercial photography when you begin, as it's almost impossible to work out how long many jobs will take.

Routine commissions such as copying artwork, or straightforward packshots in a studio shouldn't cause you too many problems. The same applies with standard location work, such as photographing a building or a fleet of cars. But jobs that involve organization and reliance on other people are unpredictable because you can't foresee delays or problems until you've done similar work.

There are two principal ways to charge for commercial photography; the one you choose will depend on the job. One is to charge hourly, the other is to charge by the day or half day. To get an idea of typical rates in your area, telephone a few photographers and pretend to be interested in hiring them.

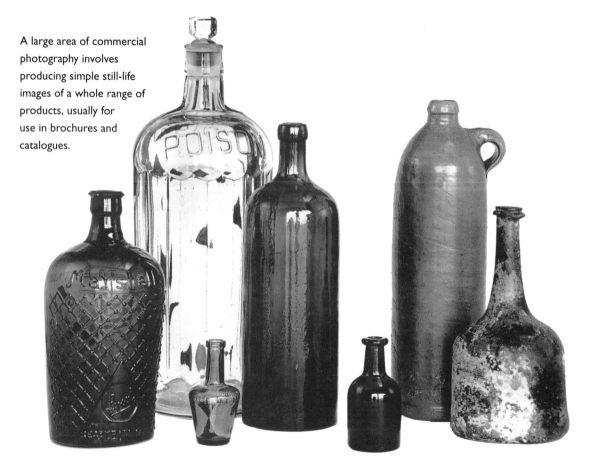

A large area of commercial photography involves producing simple still-life images of a whole range of products, usually for use in brochures and catalogues.

As well as being technically skilled, you should also possess a good degree of creativity and imagination so you can add something special to your pictures when required.

Some clients may ask you to work on an hourly basis, others may ask for an all-in price, and others still may commission your services by the day and squeeze as much as they can from you in that time. Whichever method you use, add expenses – the cost of any film and processing, a mileage rate if you have to travel and so on.

Although at first it might be tempting to offer your services at a low rate to ensure you get work, this isn't really an advisable policy in the long term for two reasons.

Firstly, once you're known for charging a certain rate, it's difficult to increase it without good reason. Secondly, if you're too 'cheap' many people may see this as a sign that you're not very good. People in business expect to pay a reasonable price for professional skills such as photography, so they won't be shocked if you charge what other photographers in the area charge. Also, while average rates may sound like a lot of money, remember that it includes depreciation on your equipment, plus any other overheads you incur.

The bottom line is, never be embarrassed about what you charge or try to excuse it. Any attempt to do so will merely give people the impression that you don't think you're worth it and they will think twice before hiring you.

Name: **COLIN LEFTLEY**

Colin Leftley studied photography at college and spent almost a decade working as a journalist on national photographic magazines. Now freelance, he runs his own commercial photography business, and undertakes varied commissions for companies in the area.

'The great thing about industrial and advertising photography is you never know what you'll be doing from one day to the next – every telephone call is a challenge. Since I began, I've photographed spectacles for an importer, fabric for a design company, building interiors, shot all the pictures for a brochure promoting a watersport centre, printing and engineering machinery, and so on.

'Obviously, this means you need to be aware of your own limitations, and the limitations of your equipment, and have the courage to turn down

work if it's out of your league, rather than saying yes and doing a bad job.

'To attract work I advertise in the business phone book. It costs me quite a lot of money for a small display advertisement, but it's worthwhile because people who don't use photographers very often look there first and I get a lot of enquiries. Also, over the years, I've found that the same people come back to me if they were happy with the first job, or spread my name around, and my client base is increasing all the time so I now receive enquiries on a daily basis.

'I'm currently in the middle of converting a large outbuilding in my garden into an office and darkroom, with an area at one end for photographing small objects with studio flash. I also use a room in my house as a temporary studio with a full width background set-up, and if I need anything bigger I hire a studio with an infinity curve – I've used that for things like motorbikes.

'It's tempting to lease or buy studio and office space, but I can't see the point. All it does is increase your overheads, so you have to charge more for each job and all your clients suffer. Doing it my way, the client only pays for a studio if I've had to hire one to do the job. This means I can keep my prices down and remain competitive. It also minimizes the financial risks.

'I approach equipment in a similar way. When I set up I had a Mamiya RB67 medium-format camera and a few lenses, a couple of battered Nikon F2s that were years old, a Nikon F-801 AF SLR, a basic Wista 5x4in kit, plus four studio flash heads with brollies and small softboxes.

Much of Colin Leftley's work is carried out in the studio, and involves producing eye-catching images of relatively plain-looking objects. His success at doing this means he is in regular demand by, among others, a top publisher of photographic magazines.

For this shot, Colin was commissioned to show the products of a fabric manufacturer in use, and worked on location using portable studio flash equipment to provide suitable illumination. Despite looking simple, such images require great care and attention to detail.

lens, for example, is ideal for architecture but using a tall tripod and standing on a step ladder will give the same effect when necessary.

'Probably the hardest part initially is deciding what to charge. There's no point undertaking jobs for virtually nothing, because that makes it difficult to increase your rates, but

'I'm still using some of that today. It may not look that attractive, but it works fine. When you're professional you have to justify spending money on new gear – just like any other self-employed person does. I tend to work to a yearly plan, and replace something different every year. I have recently upgraded my studio lighting so I now have a kit that's more portable and powerful.

'If you live and work in a big city it's easy to hire specialist equipment, but there's nowhere where I'm based, so I have to make do with what I have and work around any limitations it imposes. A shift

at the same time you can be in danger of pricing yourself out of the market. I know there are local photographers charging less than me, but there are also some charging more.

'When I receive an enquiry I ask lots of questions so I know exactly what the job entails. That way I can work out roughly how long it will take, what gear I'll need, how much film I'll use, and therefore how much to charge. The more experience you have, the easier it gets, but you need to be careful because if you make a mistake you can end up losing money, not making it.'

SELF PUBLISHING

BREAKING INTO THE calendar, postcard or book market can be a difficult and often frustrating task. Even though your work may be as good as, if not better than, the kind of material being used by publishers, you may still find yourself being turned down by them time and time again.

As we've already established in previous chapters, the main reason for this is that the needs of the market are very specific. A calendar consists of just 12 images and lasts a whole year, so calendar publishers can be very selective about which images they use – not that they always use the best. Similarly, in the postcard market, you need to strike up an amicable relationship with one or more publishers before you can hope to make regular sales, simply because it's impossible to know what their requirements are at any one time if they don't tell you.

Books involve considerable investment, and publishers need to be fairly confident any new title will be a success before committing

ABOVE AND OPPOSITE: The easiest way to succeed when publishing your own postcards is by trying to create a range that's different to the rest while still being highly saleable. This usually means avoiding the standard 'picture postcard' scenes captured in bright sunlight against deep blue sky and trying something that is a little more creative. By analyzing the market you should get an idea of what sells.

themselves. This usually means they rely on photographers who already have a track record, as it minimizes the risk. Penetrating this market is therefore very difficult if you're an unknown, despite the fact that your work may be as good, if not better than, the kind already being widely published.

One way of overcoming this underlying dilemma is to cut out the middle man and publish your own postcards, calendars or even books. Many photographers have followed this route

with great success, and if you're careful about how you approach it, there's no reason why you couldn't be successful too.

The main thing to bear in mind is that self publishing can be a great financial risk, and for every photographer who has made a handsome profit from such an enterprise, there are twice as many still licking their wounds and paying off enormous debts.

To avoid this happening to you, it's important that you spend some time analysing your motives before taking the plunge.

Here are some of the major factors to consider.

Profit or publicity?

Think about the reason why you would like to see your work in print. Is it simply for self-promotion, or do you see it as a sound business proposition that will hopefully generate profit?

If the former reason is paramount, you'll need to scale down the operation accordingly so you

won't be sacrificing hard-earned money for a quick thrill – believe me, it will soon wear off when the bills start rolling in. You could produce just one postcard from a shot of a local view, for example, and sell it to local gift shops or the tourist office. The cost to do this is minimal, it gives you a good-looking business card to send out to other prospective clients, and you can have a bit of fun. If the card sells you may then decide to produce a whole range.

However, if you're confident that your work is good enough, and you can see a gaping hole in the market that can be filled by your work, it may be worth pursuing the idea of publishing a range of cards in one fell swoop and competing with the big boys.

Quality counts

Take a long, hard look at the kind of material you'll be pitched against. Are your pictures as commercial, would you buy them if you were a member of the public? At this stage it's worth making a preliminary selection of images for whatever you have in mind, be it a book, calendar or postcards, as well as getting hold of competing material, even if you have to buy it, so you can spend time at home comparing your work against the competition.

When you do this, ask yourself how you can make your own offerings more desirable than the rest. With postcards that could mean printing on better quality card or to a larger size; with calendars an innovative design, explanatory text, inset sketch maps showing where the shots were taken from or use of more than one picture per month are all points worth considering.

Value for money is also an important factor to the buying public, so you need to strike a balance between quality and cost effectiveness. Many people will select a cheaper, second-rate postcard, for example, simply because it saves them a little money. Your priority, therefore, should be to produce something that matches or

undercuts rival publications in terms of price, but offers better quality as well.

Money matters

Once you've established what you want to sell, take a look at how much it's going to cost you to set up.

Apart from the initial outlay, further investment at regular intervals is necessary to keep the business going.

There's little point launching a set of 12 postcards, for instance, then waiting until they've sold out before reprinting or expanding the range, as your sales revenue will dry up and you won't be able to keep your stockists supplied – a sure-fire way to lose their favour and give someone else the chance to slip in through the back door.

In reality, then, a few months after the initial launch, by which time you should have some idea of how sales are going, you'll need to invest the same amount again.

With calendars the situation is a little different because you can happily launch one calendar, see how it sells, then produce one or more the following year and gradually build up your business. Adopting such an approach is a safer option, but you need to remember that by doing so, it will take several years, even if sales are healthy, to turn a good profit.

Remember also that you must produce a calendar well in advance so you can have it in the shops by July/August ready for the critical sales period towards the end of the year. Any copies not sold by the end of December are unlikely to sell unless they are offered at a massively reduced price.

Money can be saved with both calendars and postcards by careful planning. Postcards are printed in sets, for example, with different amounts on different sized printing plates – the bigger the plate, the smaller the unit cost. So instead of just having your own set of 12 printed, why not approach another photographer and see

This shot was included in some dummy pages I produced for a calendar of landscapes. Three different dummies were prepared, each containing different styles of picture, so potential buyers could offer feedback on the one they thought was most likely to sell.

if he would be interested in having a set printed too, so you can double the plate size and cut the cost of the print run? Alternatively, if you don't need the whole plate to yourself, see if you can find a local restaurant or hotel to have a card printed for their own use using one of your pictures. As well as being paid for the use of the picture, you also reduce the print bill. Additionally, you can cut the unit cost considerably by having bigger print runs of your more successful cards.

The same applies with calendars – see if the printer or paper company is interested in taking a quantity of copies in return for a reduction in the print or paper bill. You could also do the same with other local businesses if the nature of the calendar is suitable. By building up several interested parties, you can then order a bigger print run, which cuts the unit cost of each calendar by quite a margin and increases your profits.

In terms of investment, wait until you have enough cash to finance the initial launch, simply because if everything goes wrong you will not

find yourself in debt. It's tempting to raise a bank loan or work on an overdraft, but this means the risks are far higher from the beginning. These options are better left until you know you have a product that's selling.

Selling points

While looking at the type of pictures you may use, you also need to think about where the cards or calendars will be sold – in terms of regions rather than specific outlets.

Postcards, and calendars to a lesser extent, showing scenic views are usually highly regional, so there's no point offering them to shops outside the area. More general subjects, such as pets, flowers, animals and vintage cars have wider appeal, but tend to sell in smaller numbers in any given place.

Ideally, you should aim to sell your cards and calendars in an area as close to home as possible, for several reasons. Firstly, you're more likely to have the best pictures because you know the area well and have access to all the popular scenes.

Secondly, you'll have a good idea where the outlets are that may take your work, so you can save time and money researching and securing orders. Thirdly, re-stocking and finding new outlets is much easier and far cheaper when your sales patch is close to home. Remember, every extra mile you drive is profit lost.

The best possible scenario is that you actually live in a tourist area, simply because that's where the bulk of postcards are sold and you have access to a massive market. If not, consider covering the tourist area that's closest to your home.

Research the market

Conduct some market research before investing your money, and get a feel for how your work will be received. If you intend publishing a set of

Well exposed, brightly lit and attractively composed scenic pictures always make good illustrations for calendars and postcards. The key is to strike a balance between creativity and commercial suitability. If a picture is too clever, the chances are it won't sell.

postcards, have high quality colour prints made from the negatives or transparencies to the same size as the final postcard, or if you're looking to publish a calendar, put together a dummy using colour prints and card, then take them around shops and other outlets in the area where they will be on sale and gauge the response.

This is the hardest part of the process because it really is a case of knocking on doors and 'selling cold'. You may not always get a positive response

Self Publishing

– if any at all – but you must persist, because the feedback you get is always vital.

Most shop owners who sell postcards and calendars will immediately be able to tell you if a shot will sell or not, for instance, and that may influence your final picture choice. Remember, you only need two or three postcards in a range of 12 to fail through poor choice of pictures and your profit on the first print run will almost be gone.

While showing people your work, you can also get an idea of how many outlets will be willing to buy your cards and in what quantities. Many shop owners will not commit themselves until they can see the finished product, but they should give you a provisional agreement if they feel your pictures will sell. After all, they stand to make far more money than you for much less effort – the mark-up demanded by retailers is at least 100 per cent.

As for numbers, initially you only need perhaps 10 or 12 outlets, but it makes sense to keep looking for new ones once the products are on sale – you can never have too many outlets selling your wares.

Business sense

The main reason why many photographers fail miserably at self publishing is because they're great photographers but awful businessmen. At the same time, there are countless second-rate photographers making a fortune from their work because they have tremendous business acumen.

If you fall into the first category, you have two options. Either learn through trial and error how to sell – not as hard as it sounds if you're determined – or employ the services of a freelance salesperson who can sell and merchandise for you. This usually operates on a commission basis – the more they sell, the more money they earn. Ask around locally or place a small advertisement in a shop window or noticeboard – you'll probably find someone.

The first option is preferable if you're starting out on a relatively small scale as it wouldn't be financially viable to do it any other way. However, if business starts to boom, you can always take the second option and benefit from someone else's expertise.

I know a photographer who once owned a highly successful self-publishing business. He started out simply selling a set of 10 postcards. Within a few years, his cards and calendars were on sale throughout the country, he had a partner handling the selling and marketing of the range, and the last time I encountered him, he was selling over 500,000 postcards annually and making a very tidy profit. If you go about your business sensibly, instead of merely chasing a dream, there's no reason why you couldn't reach similar heights of success.

GOT THE GEAR?

You can happily shoot postcards with 35mm equipment as the small size of reproduction makes anything bigger unnecessary – compare a 6x4in print shot on 35mm and medium-format and you will hardly notice any difference.

Calendars, however, are a different matter. Medium-format should be given serious consideration as the quality of the images on the printed page will be so much better. You could even go a step further and use large-format – say 5x4in – and aim for ultimate quality.

In terms of film choice for general use, employ slow colour transparency stock – Fujichrome Velvia is my personal favourite due to its vibrant colours, punchy contrast and superb sharpness, but Fuji Provia 100, Ektachrome Panther 100X and Ektachrome Elite 100 are also highly capable emulsions.

Remember, anything you can do to make your product better than the rest will help ensure healthy sales.

117

Name: **ALAN BLAIR**

Alan Blair set up his own publishing business eight years ago. Despite a slow start and minimal investment, he now sells some 300,000 postcards every year in shops, as well as calendars and tourist books featuring pictures of local scenes.

'I never actually wanted to be a professional photographer, but when my work slowly disappeared owing to changes in the fishing industry, I found myself in need of a new career. At that time I'd had a few articles published in photographic magazines, so I joined a government-funded scheme which helped people set up their own business.

'When I started out, I didn't even have a car, so I basically had to hitch hike to take the pictures I needed. Once I had assembled a suitable set of shots, I then invested the last bit of my savings and borrowed some money from my father so I could have a set of 12 cards printed, with 3,000 copies of each card. Looking back, it was a very hit-and-miss approach. It's important to do some market research to see how people react to your work, but in the end you just have to make the decision about what is likely to sell. There's little point in showing potential buyers a set of 35mm slides because you can't see what's going on. Postcard-sized prints are an option, but I always found that the print quality was never good enough.

'Nevertheless, I did spend a lot of time knocking on doors and asking to see the manager or owner of shops that were selling postcards in the area, and I received a lot of useful feedback – like people telling me which shots they thought would sell and which wouldn't.

'My first set was met by mixed reaction. Four shots sold really well, four were so-so, and four completely failed because the scenes depicted weren't local – a stupid mistake to make, but one I think I had to make. You live and learn. Soon after, I had a second set printed featuring different scenes, and started looking for other outlets just outside my original sales area. This effectively tripled the sales potential because I was able to offer different sets in different areas, but it only doubled my costs.

'It took a year before I saw any profit, but I think you need that level of commitment to make it worthwhile. I know of photographers who will have maybe two or three cards produced, but it's a waste of time. Shopkeepers laugh at you, when you try to sell them in, and the cost of travelling around trying to sell them means you'll never even break even. Basically, the more cards you have to offer the more cost effective it becomes because you stand to make more profit from each visit.

'These days I have two ranges of postcards on sale – a slightly larger

set of moody shots printed on high quality card, and smaller standard-sized cards featuring the typical blue sky, white cloud scenes. In total there's about 140 different cards.

'Getting started in the postcard business is difficult, because you never really know what's going to sell until it's on sale. However, after a year or two, you begin to get a better feel for the market and know instinctively which pictures to publish. I still produce the occasional card that takes ages to sell, but I'm getting better!

'Last year I also produced my first calendar. This I did in cooperation with a paper manufacturer who took 200 copies in return for money off the final bill. It meant I had to sell at least 3,000 just to break even, but in the end I sold all 4,800 copies, which I felt was satisfactory.

'The most important aspect of self publishing for me is establishing a good relationship with your outlets – I have about 70 now in my local region. It's vital that you maintain regular contact. There's no point waiting for a telephone call asking for more cards, because shopkeepers expect you to telephone them and make sure stocks are high. During the summer, which is the busiest period, I visit them all at least once a week. If you don't re-stock, you're losing money and goodwill. It's easy for a shopkeeper to forget about you, and if you aren't careful it's even easier for another photographer to take over.

'Publishing postcards and calendars for a living may sound idyllic, but it's a volatile market and takes a lot of effort. At one point, I was working 110 hours per week for three months, without a break, and I haven't had a good night's sleep for two years!'

Here are three of Alan's best-selling postcards showing scenes in East Anglia, England. Each has sold many thousands of copies and been part of the range for several years.

SELLING ORIGINAL WORK

THE ULTIMATE TEST OF TALENT has to be organizing an exhibition of work for the general public to enjoy. Imagine it: groups of people wandering around a room whispering encouraging remarks about your work. People you've never met before lavishing you with praise and critical acclaim for being such a brilliant photographer....

Most of us never find out because we opt out at the dreaming stage, scared off by the risk of rejection. Photographs are very personal creations, and having them criticized can be a real confidence killer. It's like being told your baby is ugly.

The logistics and cost of organizing an exhibition also tends to dampen the spirits, so we play safe and never show our pictures to anyone other than family or friends.

But organizing an exhibition needn't be as frightening or as expensive as you think, and the financial rewards could prove immeasurable – as well as offering your pictures for sale, you're also publicizing yourself, which could lead to lucrative commissions.

Planning your exhibition

The first step in organizing any exhibition is to come up with a suitable theme. This could be a photographic study of a specific place, event, or group of people, or if you specialize in a particular subject such as landscapes, portraits or nudes it could simply be a selection of your best pictures taken in the last year. The important thing is to have a link between the pictures that will make people want to look at them, rather than an exhausting variety of 'nice' shots. If you're unsure of how to approach this, visit a few local exhibitions yourself.

Next, you need to make a preliminary picture selection. This can vary in quantity from 10 to 50 or more, depending upon the theme and where you hope to exhibit, although 25–30 seems to be an average number. Every shot must be technically flawless, so reject anything that isn't pin-sharp and well composed, and if you're hoping to sell prints, choose the kind of shots that you could imagine people wanting to hang on the wall of their home, office, showroom or other business premises.

Ideally all the pictures should be printed up specially for the exhibition to the highest possible standard, so discard any prints that don't make the grade, no matter for what reason. In terms of size, 16x12in (40x30cm) or 20x16in (50x40cm) is ideal, although there's nothing to stop you using smaller or larger prints. Photographers who specialize in selling fine art prints tend to adhere to a standard size, such as a 16x12in (40x30cm) image on a 20x16in (50x40cm) sheet of printing paper. Having this kind of consistency also makes buying frames in bulk much easier, and adds a certain style to the exhibition.

When choosing pictures for an exhibition, ask yourself if people are likely to want to buy them to hang on their wall. Images with a fine art quality tend to be the biggest sellers, and creative black and white work is one of the largest areas of fine art photography with commercial value. This picture would be ideal for an exhibition.

Make sure all your exhibition pictures are neatly presented in simple frames with accurately cut window mounts.

Mounting and framing

This tends to be the most costly part of an exhibition, so it pays to shop around. You may be able to save money by going direct to the manufacturer, getting a discount from the retailer for buying a large number of frames, or negotiating with a local picture-framing company whereby the frames are made at a discounted price in return for a few original prints. Try it – you can only be told no.

Clip frames are the cheapest option, and they're also very simple, so the print itself and the border surrounding it create the impact, while the frame simply holds it in place.

That said, frames with a narrow border tend to look far more impressive because they pull everything together. Stick to a simple colour, such as black, chrome, pine or dark wood, and use the same design throughout. These frames will cost you more, but they do a better job, and you can always re-use them for a future exhibition. In terms of size, choose a frame that will give at least a 2in (5cm) border around the print – 20x16in (50x40cm) frames are ideal for 16x12in (40x30cm) prints.

You also need to make provision in your budget for mounting board. Daler board is the most economical in the UK, and can be purchased from your local artists' supply shop. However, acid-free, archival or museum board is preferable, as it doesn't contain chemicals that may cause fading or discolouration of the print long term – an important consideration if you're hoping to sell prints. This can be purchased from specialist photographic suppliers. Stick to a neutral colour such as white, cream, ivory or grey throughout, and buy card that's at least 1,400microns thick.

Bevel-edged window mounts provide the most effective way to show off prints. If you don't mind paying the extra, you can have the mounts cut professionally by a local picture framer – it shouldn't cost much per mount. However, if you intend to exhibit on a regular basis, it's worth buying a cutting rig and doing your own to save money. There are various mount cutters available from manufacturers, which allow you to cut perfect bevel-edged window mounts quickly and easily.

Here's a quick step-by-step guide to cutting a window mount with one model of mount cutter.

1 Measure the print and mounting board and note the dimensions. Now subtract the length of the print from the length of the board then divide the answer by two. Do the same for the width. This will give you the border sizes.

2 Using a ruler, measure the border widths and mark their position for all four sides on the edge of the card. Now join the marks together with a feint pencil line so you have the cutting lines for the window.

3 Take your cutting tool and align the blade with one of the pencil lines. Carefully push the blade into the board and run it along the pencil line to make the first cut. Repeat this for the other three sides then remove the surplus card to reveal the window.

5 Turn the mount over so the back of the print is revealed, and place a length of archival masking tape along each edge of the print so it's held securely in position. The mounting procedure is now complete.

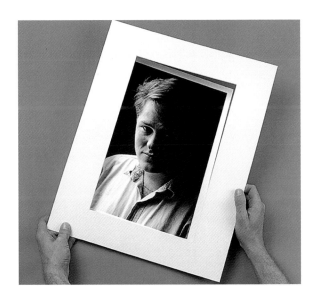

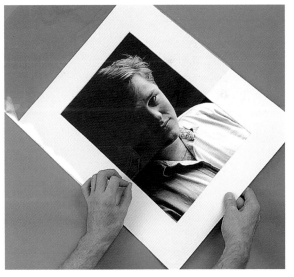

4 Place a small piece of neatly cut archival masking tape on each corner of the print with the sticky side facing up, then carefully lay the mount over the print and press the corners down so the print is held in position behind the mount.

6 If the prints are to be sold unframed, place them in transparent archival polyester sleeves which are available from most professional darkroom and picture presentation specialists. These not only look very neat, but they protect the print from damage.

When you come to hang the prints, give plenty of thought to their sequence. In galleries it's traditional to hang each picture in isolation so visitors can look at them as they walk around the room, but in libraries, restaurants and many other venues you may be limited to just one wall, in which case the prints will have to be grouped together. Decide on the group by arranging the frames on the floor first, then use a spirit level and tape measure to ensure they're perfectly square and equally spaced on the wall.

Choosing a venue

The most important stage in organizing an exhibition is finding a suitable venue where your work can be displayed. There are many galleries around the country that specialize in photographic exhibitions, but they tend to be reserved for well-known names and have a long waiting list, so in the beginning you're advised to aim lower and look at smaller, local alternatives.

Cafes and restaurants have become highly popular in recent years for displaying pictures because the customers can look at your work while enjoying a meal or drink, and the owners can fill their walls with attractive photographs free of charge. Local art galleries, libraries, museums, schools, colleges, camera clubs, hotels, town halls, community centres and shopping malls are also worth checking out.

Compile a list of possible venues, then write to or telephone the person in charge and arrange an appointment to show a selection of your pictures. If all goes well at this stage you can discuss possible dates for the exhibition, take a look at the amount of wall space available, and sort out any financial matters; the venue owner/manager is likely to request commission from any sales made, for example.

Publicizing the exhibition

There's no point in organizing an exhibition if no one knows where and when it will be taking place, so once dates, times and venue have been confirmed, start publicizing it.

The easiest way to do this is by typing out a 'press release' which gives all the relevant details, then sending a copy, along with a 7x5in (17.5x12.5cm) or 10x8in (25x20cm) black and white print of one of the exhibits, to local newspapers, county magazines, the local radio or TV station, colleges and anywhere else you

Fine art prints for exhibition or sale can feature more or less any scenic subject – it's the way you photograph the subject that counts. Here an old stone bridge in the grounds of Dunster Castle, Somerset, England, was captured using Kodak High Speed Infrared film to add an eerie, grainy feel to the scene.

can think of. You may also be able to display a 'flyer' in shops, colleges, community centres, libraries and other places, and most photographic magazines include details of forthcoming exhibitions, so contact them at least two months in advance.

Most exhibitions have an opening night where invited guests can enjoy a drink while viewing your work. This isn't always possible with some venues, but if you have the option it's well worth considering because you can invite people who may be beneficial to you: the press, representatives from advertising agencies and design groups and local businessmen.

If you can afford to, have the invitations specially designed and printed – a contra deal with a local printer could save money – and send them out early so your guests have plenty of notice. This not only increases the chance of them being able to attend, but gives you the option of inviting more people to boost the numbers if you receive rejections.

For the food and drink, either organize this yourself, ask a friend, or employ a local caterer. Ideally, you'll need wine or beer, soft drinks such as fresh orange juice and mineral water, as well as a selection of little 'nibbles': cheese, olives, corn chips, dips, etc.

What it costs, what to charge

Organizing a large exhibition can be an expensive project if you shoulder the burden alone, so once the venue and dates have been confirmed, why not try to get sponsorship from local companies to help cover your costs? It's doubtful that anyone will hand over hard cash, but you could ask a picture framer to loan you the frames, or a local laboratory to prepare the prints, and so on. In return, offer to display the company logo, mention them in any publicity handouts, and make their business cards available to the exhibition visitors.

No matter how much help you get, however,

you will need to sell quite a few prints to cover your costs and make a profit. There are two ways to do this – by offering the framed exhibits for sale after the close of the exhibition, and selling window-mounted original prints of the same pictures during the exhibition. The owner/manager of the exhibition venue may be happy to take orders for you, or you could leave behind a selection that can be sold on the spot.

To sell the framed exhibits, place a price label on each frame – if they're all the same size, they will probably all be the same price. An unframed price can also be included so people know what you're charging for mounted original prints.

If you're selling on a limited edition basis, each print should be numbered and signed by you for authenticity, and you must not sell more than specified by the edition, whether it's 10, 50 or 100. Many photographers don't bother with limited editions, as most people are happy knowing they've bought an original print. Include a business card with each print so the buyers can contact you in the future or pass on your details to friends.

Deciding what to charge for prints is difficult, but don't undercut yourself – attend other exhibitions and visit galleries to see what other photographers charge. A few simple sums will help you determine your charges, so that you are able to cover the costs of the exhibition by selling 10 framed prints and any sales over and above that number are clear profit.

Obviously, these are ballpark figures that don't account for any commission you may have to pay to the venue, or any money you can save by doing deals at the early stages. What they do show you, however, is that it is possible to make money from the sale of original prints, and once you have a few local exhibitions behind you, there's no reason why you cannot move up in the world and start exhibiting at proper photographic galleries, where original work is often offered for sale on a full-time basis, long after the exhibition has closed.

Carefully printed black and white images are ideal for private sale or exhibition. This moody rendition of London's Thames Embankment looking towards St. Paul's Cathedral was shot on a dull, overcast day when the light was very soft using grainy ISO1600 Fuji Neopan film. The negative was then printed through a soft focus filter to create the ethereal glow, before toning in sepia toner to add the delicate warm colour.

Name: **JOHN POTTER**

Over the last five years, photographer John Potter has organized six exhibitions of his work at various venues. Here's how he went about it.

'My first exhibitions were combinations of landscapes and portraits, and I held them in libraries. Both were successful and the libraries proved to be good venues, even though it wasn't obvious that they would be. These days, I use larger venues. I have two exhibitions coming up, at a college and a newspaper headquarters. The subject this time is regional landscapes, and the exhibition will comprise a series of 28 colour prints.

'My main reason for exhibiting now is to give myself a reason to produce a body of work, and also to promote myself. It usually costs quite a lot of money to fund an exhibition, but I can cover those costs by selling original prints during the exhibition. I also cut all my own mounts, and make the prints at home in my darkroom to save money.

'Entry to the exhibitions is free, but I promote it as much as possible by contacting local newspapers, TV and radio stations, colleges, libraries and anywhere else I can think of. Usually I produce a small poster on my computer at home, make small prints and laminate them in plastic so they can be sent out with the details.

'All the prints in the exhibition are offered for sale. I don't bother with limited editions because people don't seem to mind one way or the other.

'By the end of the exhibition, I've usually sold enough prints to cover my costs. The main benefit, however, is that so far I've received a number of

John Potter puts a lot of effort into publicizing his exhibitions to maximize potential sales. Leaflets giving details of prices are printed on his home computer, along with posters on to which colour prints can be mounted. This gives a very polished, professional image.

commissions on the strength of the exhibited work, so that's where I make a little additional money. In the near future some of my landscapes should be appearing in a book, for instance.

'I also showed some work at a local craft fair, and afterwards was asked to display some of my work in a local shop and the waiting room of a dental surgery. I've since sold quite a few prints through these outlets, and hope to develop that side of the business further.'

Here are two pictures from John's recent landscape exhibition. This proved to be a resounding success, with print sales covering all his costs and providing a handsome profit. Spin-offs also included the sale of nine pictures for use as postcards, a request for another exhibition and a possible book project in the near future.

WINNING PHOTOGRAPHIC COMPETITIONS

WIN A BRAND NEW CAR! Win a two week cruise in the Caribbean! Win a mountain of photographic equipment! Win a complete home darkroom! Win, win, win!

These are the kind of irresistible headlines you'll find gracing the pages of many magazines, newspapers and circulars practically every month of the year. All you have to do to win, it seems, is take a good picture, fill out an entry form and you could make a fortune.

Obviously, life isn't quite that easy, but there's no denying that photographic competitions can be a lucrative source of extra income if you put effort into entering them – as many photographers have discovered. I know of one who won a brand new car several years ago; another who won a Hasselblad camera and put it up for sale in the next issue of the very magazine that gave it to him!

Every competition must have a winner, and if you look upon entering them as a serious enterprise rather than a bit of fun, there's no reason why it couldn't be you.

Where to find competitions

First of all you have to find a competition, but that shouldn't be too difficult as they tend to appear all over the place.

The photographic press is an obvious starting point, as the various magazines run at least one competition per issue and the prizes are usually highly desirable. Then there are the larger competitions run annually by photographic companies such Nikon and Olympus, some of which receive entries from all over the world.

The only snag with competitions run by the photographic industry is the entrants are active photographers, so the standard is very high and your chance of winning is reduced. However, competitions run by companies outside the photographic industry, such as magazines, newspapers, TV guides, book clubs, travel companies, soap-powder manufacturers and so on tend to be entered by people who don't know one end of a camera from another, so the odds of success are much higher. The prizes also tend to be more desirable, ranging from foreign holidays (during which you could shoot stock!), to large amounts of cash.

A word of warning though. Occasionally, unscrupulous companies mount competitions in which the entries are non-returnable and all copyright on them becomes the property of the sponsor. In real terms, this means for the price of a few, insignificant, prizes, the company concerned could find they own hundreds of

If you are entering black and white pictures for a competition, always make sure they are of the highest technical quality as this will have a strong influence on their success.

pictures which they can use completely free of charge and as often as they like.

If you don't mind sacrificing the copyright of a photograph for the sake of entering a competition, that's your choice, but I'd advise you against it.

Assessing your chances

The next step is actually entering the competition. This may seem obvious, but most of us have thought about entering at least one competition in the past then decided against it at the last minute, assuming there will be far better pictures than our own.

The truth is, the majority of photographers are stricken by the same lack of confidence, so the actual number of entries, even to a major competition, is much smaller than you might think. With magazines, the figure is usually less than 1 per cent of the readership. A magazine selling 50,000 copies can therefore expect around 500 entries, if it's lucky. Also, of all the entries received, only a very small number – usually about 5 per cent – will actually stand any chance of winning. The rest will either be unsharp, poorly composed, badly exposed, plain boring, break the rules or fail to fit the brief. That basically means in a competition attracting 500 entries, only 25 will be any good, so if you can take a picture that falls into that elite 5 per cent you're already well on the way to a prize.

Read the rules

The first thing you should always do when entering a competition is read the rules thoroughly – at least once – so you know exactly what the judges require.

It is pointless submitting prints when they want slides, or three pictures when they want two. And finding out when the closing date is will give you an idea of how much time you have to put your entry together. With these details

confirmed, you can then get to work on the theme.

Most competitions have a set theme – often it's a generic subject like portraits, landscapes or children, while some might ask you to capture

the spirit of a season or illustrate a single word.

Ideally, you should think carefully about how you can interpret that theme. Different photographers have different approaches: some

Competition entries should be of the highest possible standard, so reject any images that are badly exposed, unsharp, poorly composed or simply uninteresting.

Producing images that have immediate appeal will stand you in good stead. Most photographers take the easiest approach when it comes to interpreting a competition brief, so anything you can do to make your entry original, unusual or attention-grabbing has to be a good thing.

scribble some words, others make sketches; but providing it stimulates you into action you can do anything. It's probably wise to dismiss the first ideas that spring to mind though. It is likely that they will be too obvious and probably shared by hundreds of others.

What the judges want is originality. They want to see pictures that have been carefully conceived, subjects that have been approached in a fresh way. Spend time executing an original, eye-catching entry and you have an excellent chance of success.

One of the biggest mistakes made by photographers is to take the lazy route and rifle through their picture files in search of a suitable entry. There's nothing wrong with this approach, and it's always a good idea to establish what you already have.

The problem is, under normal circumstances, we shoot to satisfy ourselves rather than someone else, so it's doubtful you'll find an image that does the job perfectly. More often than not, you're better off shooting specifically for the competition. That way you can make sure everything fits the judges' criteria perfectly. Another advantage of doing this is that after a while it becomes much easier to interpret competition briefs – practice makes perfect – and as a result your success rate should rise.

Make sure your entry is technically flawless. Sharpness, exposure, focusing and composition are all taken for granted, and you can guarantee that if your effort falls short on one of these points, the picture from the next entrant will not. So always use a slow film unless the grainy effect of a faster emulsion will enhance the final result. Use a tripod to prevent camera-shake where necessary and bracket your exposures to be sure of getting at least one frame exactly right. Compared to the value of the prizes on offer, the cost of a roll or two of film and a few hours of your time pales into insignificance – or at least it should do if you intend winning.

Presentation counts

This brings us conveniently on to the subject of presentation. At the end of the day, it's the quality of your picture that counts, but the way you present that picture is equally important. If you present your entry well it is certain to win favour with the judges.

For prints, the 6x4in colour enprints will impress no one. So read the rules again, find out what the maximum print size is – usually no more than 16x12in (40x30cm) – then have an enlargement made. A good size is 10x8in (25x20cm). If you do your own printing, make a fresh one. Mono prints should exhibit a full range of tones and be spotted to perfection. Anything less, and they'll be making their way back to you

in no time at all.

Check the rules to see if mounted prints are accepted. If they are, then mount the print on card – a window-mounted print with a 2 inch border presented in a clear polyester sleeve will look super. If mounting is not permitted, then submit the print as it is, ideally with a neat white border around the edge.

It is the same for slides. Your entry needs to stand out from the mediocre crowd, stop the judge in his tracks, make him want to take a closer look. The majority will be supplied as 35mm, so if you can shoot on medium-format or even large-format you have an immediate advantage because your picture will loom much larger than the others on the lightbox. An alternative is to have a high quality 6x9cm duplicate slide made from the 35mm original.

Avoid mounting slides in glass. They invariably break in the post, and nothing is more off putting than having to pick slivers of glass out of a package, or your fingers!

Packaging your entry

Finally, always make sure your entry is packaged well but easily accessible. Do not cover the outside of the envelope in layers of sticky Sellotape, and never seal prints or slides in six layers of polythene or wrap them in sheets of tissue paper. It really is unnecessary.

An ideal entry would arrive in a padded or card-backed envelope, possibly between two pieces of stout card for extra protection, along with a completed entry form, a letter providing technical information about the picture where necessary and a separate stamped addressed envelope for its safe return (see page 57).

These may sound like minor points, but they really do matter. Entering a competition is rather like applying for a job – you need to impress the people receiving your application from the beginning, otherwise another candidate will be chosen.

Name: **STEVE MARLEY**

Steve's interest in photographic competitions began over a decade ago. After 48 unsuccessful attempts, he finally managed to have a picture placed in the top twenty then went on to win several competitions. Overall, he has won prizes worth thousands of pounds as well as having his name mentioned in some 60 competitions.

'It took a long time before I managed to win any competitions, but instead of giving up I would compare my failures with the winning pictures and try to fathom out why I hadn't won and why they had. I still do this today because it's very important. The secret is not to be dispondent if you lose, but to carry on.

'I can't really say what the secret to my success is, but whenever I decide to enter a competition, I always give it 100 per cent. I start by carefully planning my approach and dreaming up ideas that fit the brief. I'll look up the word in a dictionary, for instance, to get different angles on its meaning, make notes and do a lot of thinking, brainstorming, so I can produce an entry that will be different, original and creative.

Steve has learned through trial and error – he entered 50 competitions before winning any – that unusual techniques make an image stand out on the judge's lightbox, so whenever possible he likes to try something different. In this case a zoomed effect used on a shot of Trooping the Colour in London has turned a common subject into a powerful, creative image.

Steve Marley's charming portrait of a young Chinese boy in traditional uniform has found praise among competition judges on several occasions and scooped a variety of excellent prizes.

'I never just dip into my collection of slides and send off the first shot that looks half good. That's what most photographers do, so by putting more effort into my entry, and shooting something specifically for a competition, my chances of winning are increased.

'Something else I've discovered with photographic magazines is that straight shots rarely win. You need to come up with something striking that will stand out from the crowd and catch the judge's eye. So I spend a lot of time experimenting with unusual techniques and alternative approaches to popular subjects.

'Of course, I still have failures. But I never actually enter to win and once I've dropped my entry in the post I forget about it.

'Winning is just a bonus. I get a lot of pleasure from entering competitions because it gives me a perfect reason for going out and taking pictures, what I enjoy doing most.'

SHOOTING
STOCK

ONE OF THE MAJOR PROBLEMS associated with freelancing on a part-time basis is lack of time. If you have another job that occupies you from Monday to Friday, the only periods left in which to take pictures are evenings – if you're lucky – and weekends, and the few weeks every year that we're entitled for holidays. This is actually a large chunk of time if you add it up, but to make money from your photography you also need to sell pictures as well, and that in itself can be very labour intensive.

Stock shots needn't always be taken in a conventional way. I took this zoomed picture of London's Piccadilly Circus and it has proved to be a big seller on the international circuit because it sums up the fast pace of life in the city and shows two subjects that are common to it: a famous landmark and a red London Bus. For the sake of a few frames of film it's always worth shooting unusual images – the library can always reject them if they are uncommercial, but what often happens is they become the biggest money spinners.

Sunsets are always good stock images because they can be used to illustrate so many things, from a specific location to a mood.

BELOW: The best stock travel pictures are those which sum up a location in a single image. Here a mist-filled valley captured near the Tuscan town of San Gimignano sums up perfectly the atmosphere of this region of Italy.

A further obstacle which trips up many photographers is actually knowing how to sell their wares - there's little point in posting off pictures willy-nilly to magazines and publishing houses if you don't actually know what they want and when they want it. If you do, chances are those pictures will be dropping on to your doormat again within days.

A great way to overcome both these problems is by lodging your work with a picture library, so all the selling is done for you. This, in turn, frees you to spend the time you have doing what you do best - taking pictures.

Most libraries operate along similar lines - photographers submit work on a regular basis, this is edited, the library keeps the shots they think will sell, then they go about marketing them to anyone who needs pictures: publishers, advertising agencies, TV and radio stations, businesses, travel companies, and so on. Many libraries also produce glossy colour catalogues of their most saleable images which are sent to regular clients and to other libraries around the world who act as agents and sell the stock in their respective countries.

In return, the library usually takes a 50 per cent cut from all sales and the photographer takes the other 50 per cent - a good deal considering the number of markets to which your work is exposed. Of course, I've simplified matters here enormously to give you a taste of what stock photography is all about, but to make a success of it you must be committed and patient.

People pictures are in big demand in the publishing industry, so it's worth adding them to your list of stock subjects. This candid shot of people buying groceries was captured in a local market.

A numbers game

The most important thing to bear in mind before approaching any library is that stock photography should be thought of as a long term investment. Many would-be contributors think that all they have to do is send off their latest batch of holiday pictures then sit back and wait for the money to roll in. Unfortunately, it isn't that simple. When a new photographer joins a library it could take

many months before their work is even integrated into the filing system properly. Everything is computerized, and many libraries re-mount everything they take. After that, it can also take one, perhaps two years for the pictures to start selling, if they sell at all, and as much as five years before you see regular returns.

For this reason, most libraries stipulate a minimum retention period of two or three years. If they didn't, some photographers would recall

their work after 12 months because it hadn't sold, wasting a vast amount of time, effort and money on the library's part in the process.

Equally important is the need to increase the number of pictures held by the library on a regular basis. If you just send an initial batch of 200 shots and don't follow up with more pictures, you may never make a single sale. However, shooting pictures specifically for the library as often as possible, your stock will build up rapidly and that's when you'll start to see the financial benefits. It's a case of the more pictures you have on the files, the more you're likely to sell.

I personally know amateur photographers who have anything between 5-10,000 pictures with libraries that they've built up over a number of years, and sell enough to pay for all their equipment, film and processing, and to finance stock trips to some very exotic places. I also know a professional photographer who shoots stock full-time, travels the world, and has over 50,000 pictures with one of the world's top libraries.

Choosing a library

Deciding which library with whom to place your work can be a frustrating business, mainly because you will not know if you've made the right choice for several years, by which time it's a little late to regret your decision.

To prevent this happening, you need to study the market and shortlist libraries that may be suitable. Photographers' handbooks usually feature a section on libraries and most countries throughout the world publish one that is specific to that country (see page 152).

If you specialize in one subject area, such as sport, natural history or travel, it may be worth looking at libraries that specialize in that area too, as they will give your work exposure to the right people. Most libraries, however, cover all subjects and deal with all facets of publishing, advertising and media, so in theory they offer a much bigger market place.

The vast majority of picture libraries are usually based in or close to the capital city of each country, mainly because that's where the heart of the market is – all the big book, newspaper and magazine publishers, all the major advertising agencies and TV stations can be found there. With that in mind, it makes sense to go for a library based in the capital. At the same time, if you specialize in subjects that are relevant to a specific area it may be better to look at libraries anywhere in the country as they are likely to have a ready-made market for your work.

There is also nothing to stop you contributing to overseas libraries. If you live in the USA, for example, you could supply a library based in London, Tokyo, Sydney or Munich, and vice versa. I know one photographer who has pictures with ten different libraries throughout the world, and

finds that this is more profitable than placing all his work with one library.

In terms of library size, it's tempting to try the biggest and the best, thinking it will automatically make you rich. Unfortunately, this isn't always the case. The bigger libraries do have a bigger market, higher turnover, perhaps better overseas distribution and possibly the ability to charge higher fees, so in theory the sales potential of your work is increased. But at the same time, the files will be well established, making it more difficult for you to produce something different – especially in the area of travel – and your work will be competing for sales with that of hundreds of other photographers, many of whom are world-renowned.

If you have several thousand top quality stock pictures available now, trying to become established with one of the bigger libraries may

ABOVE AND OPPOSITE: Many of the leading picture libraries now accept black and white images for their files as there is a growing demand for this medium in the world of advertising and publishing. Ideally you should copy the prints onto medium-format colour transparency film such as Fujichrome Provia 100, so the images can be supplied as colour transparencies, making them much easier to handle.

make sense because you can make a reasonable impression from the start. However, if you're more or less starting from scratch, it's better to look for a library that is still becoming established, so you can grow with it. This may mean you have to sacrifice sales in the early days, but in the long term it will pay because you'll be able to shoot on demand and fill the files with pictures that people are requesting.

As an example of this, landscape photographer, Alan Blair, spent two years actively looking for a library before settling for one of his choice.

'There weren't many landscape photographers contributing at that time, and the files had lots of gaping holes, so I could see the potential for development. Other libraries I tried didn't seem as positive – they had a "take it or leave it" attitude which I didn't like.

'After joining, I immediately began visiting areas of the country that weren't covered by the files, and started filling the gaps. The owner also gave me a lot of encouragement and direction. Today I have over 8,000 pictures with the library, which is now one of the biggest and best, and I enjoy regular sales. That's mainly because I made the effort to photograph subjects the library needed rather than what I fancied, but also because I joined the library when it was still growing. Had I joined a bigger library I think the situation would have been a lot different.'

Once you've put together a shortlist of perhaps six libraries, it's worth getting in touch and asking them to send out any information packs they might have for new contributors, plus a copy of their latest catalogue. Libraries that don't produce catalogues should be put to the bottom of the list. They may be successful, but as much as 75 per cent of the business is generated by catalogues, so they represent a massive earning potential.

Scenes depicting heavy industry can be good sellers, especially if you shoot them in a generic way. This factory belching smoke into the atmosphere was captured at sunrise to add atmosphere and could be used to illustrate many different themes.

By submitting work to a picture library you are able to make sales in markets that would be impossible to approach as an individual. Here are two tearsheets from my picture library, showing photographs used on the cover of a photographic magazine and inside a national newspaper.

After that it's a case of making a final decision. If you have a lot of pictures, it's worth visiting the library offices so that they can see your work and you can inspect their organisation. However, if all you have got to offer is the minimum submission, you are just as well sending it by post after checking that this procedure is acceptable, then waiting for a response. If you are accepted, you can then arrange a visit to look around the offices, talk to the picture editors and therefore determine some idea of the library's immediate requirements.

Finally, a word of warning. Avoid any libraries that charge a 'registration' or 'membership' fee to new contributors. Reputable picture libraries do not do this, as they make their money from picture sales, not gullible photographers.

To help prevent this kind of thing happening there are various regulatory bodies; in the UK, it is known as BAPLA (British Association of Picture Libraries and Agencies) and similar bodies exist throughout the world. If the libraries you have shortlisted are member of BAPLA, then you know you're dealing with a reputable company.

For details of picture libraries throughout the UK, Europe and the USA, refer to page 155.

What they want

Most libraries will ask you to sign a contract when you join which may ask for exclusivity. In other words, you cannot submit the same pictures to another library, or market your own work. Many photographers do supply more than one library, but it's always with different pictures. And if they do sell their own work as well, the library is informed of any changes in copyright on specific pictures.

This is done mainly to protect all parties involved and maintain the library's integrity. If two libraries hold the same work, for example, it's quite conceivable that the very same shot could appear on the covers of two magazines at the same time – not a good way to enhance anyone's reputation.

Accurate captioning is also essential, otherwise the library could face embarrassment if they sell a picture that has incorrect information on it. The onus is on you to make sure this doesn't happen, so don't write anything on the mount if you're unsure – say so. I keep location notes if I'm visiting an area for the first time, and refer to maps of the area on my return, if only to make sure I spell the place names correctly!

Some libraries prefer to re-mount everything. If yours does, submit the pictures in strips of unmounted film with caption notes on the

Traffic trails on busy roads and other transport images can easily be photographed close to home but often have international appeal. Although this picture was taken in the author's home town, there are no indications of its location, so it automatically becomes a generic traffic shot.

sleeves. The library can then cut out the frames they want and return the rest.

If the library prefers you to mount your own, then do so. Use self-adhesive card mounts, as they're cheaper than plastic, and follow any instructions for captioning. Usually the top strip must be left for the library's stamp, while the bottom strip can be used for the caption. Handwritten captions are fine if you have a neat writing style, but a much better method is to type

out the captions on small labels which you can then stick to the mounts. I do this on my computer with a special software program, which allows up to five lines of type to be printed on labels that are just big enough to fit on the top or bottom strip of a 35mm slide mount.

In terms of format, most libraries will accept 35mm, but medium-format is preferred. This is mainly because the bigger original tends to generate more sales, and also because it can be reproduced much bigger, thus earning higher reproduction fees. If you intend photographing stock in a big way, it would be worth investing in a medium-format camera system. I use a Pentax 67 kit, which produces impressive 6x7cm images that look superb compared to 35mm. Having spoken to many photographers about stock, it seems the 6x7cm format is the favourite.

Finally, many libraries are even particular about the type of film you use. Until a few years ago, Kodachrome 25 and 64 and Fujichrome RFP50 or RDP100 were preferred, but today Fujichrome Velvia is by far the most popular choice due to its vibrant, punchy colours, fine grain and incredible sharpness. You can get away with using other films, but where possible it's worth sticking to the preferred brand.

Knowing what to shoot

The whole idea of shooting stock is to make money, nothing more, nothing less, so deciding what and what not to shoot is something that needs to be given serious consideration.

If you simply want to cover the cost of your film and processing, then you'll probably be happy to just shoot whatever takes your fancy, when it takes your fancy, and hope that some of your pictures will sell. This is basically amateur photography taken one step further. However, if you intend stock photography to be a profit-making venture you need to think more carefully about the type of subjects you photograph, otherwise you could invest a lot of time and

money and get nothing in return.

First, consider the type of pictures you take and how commercial they are. It's almost impossible to look at a selection of stock images and say which ones are going to be bestsellers, but you can be sure that some subjects sell better than others.

Landscapes are highly popular, for example, but they tend to generate relatively small reproduction fees unless you have something really special or different. To make a good income from them you therefore need to have thousands of pictures in the library's files, so lots of small sales add up to a respectable amount. At the other end of the scale, subjects like business and commerce tend to generate higher reproduction fees, so you can make a lot of money with just a few pictures, providing they are of the highest standard.

Obviously, you can't suddenly switch from one subject to another just to make money, simply because they all require different skills. However, you can change direction slowly and start adding more commercial subjects to your repertoire. You can also increase the chances of making sales by actively trying to plug holes in the library's files, instead of shooting for the sake of it and merely duplicating shots that are already there.

To do this, you need to speak to library staff on a regular basis and look closely at any 'wants' lists they issue, so you're aware of any special requirements and can respond to them. You may like the idea of spending a week photographing a particular area, for example, but if the library is in desperate need of shots of another location, you're better off going there instead. Or on a different level, if you've set your heart on photographing a certain area, find out if there are any specific shot requirements for that location.

Cost-effectiveness should also be given serious consideration if you see stock as a long term investment. A fortnight taking pictures in the Bahamas may seem idyllic, but if it uses up your capital for the rest of the year, perhaps you're

being a little over-ambitious and the money would be better spent on less expensive and potentially more lucrative trips.

Most travel stock photographers begin by covering the places that are closer to home during holidays and weekends – places that are cheaper to get to, but still highly commercial. That way, they can build up a sizeable collection of pictures without having to risk a fortune. They then use the profits those pictures generate to fund trips to more exotic places. For example, on an international level, shots of London and Paris are just as commercial as New York or Sydney, but if you're based in the UK the first two locations are far more accessible, while New York will suit photographers from the USA, and so on.

Another way to build up your stock as cheaply as possible is by looking for commercial subjects close to home – no matter where you live you're bound to find something. Over the years I have taken many saleable stock shots within five miles of my home, including traffic trails on the main roads, sky shots for use as backgrounds and a series of shots of the same scene during every season of the year.

The key to success is looking at things laterally, rather than literally. At night, one busy road looks pretty much like any other. Similarly, subjects such as fluffy white clouds against deep blue sky can be taken anywhere – the people who use them are interested only in the visual effect.

To get a feel for the type of stock pictures that do sell, all you need to do is thumb through one or two catalogues from your library. This can be quite a liberating experience, as it shows that you needn't travel to the ends of the earth to produce saleable work.

Summing up, the key to success with stock photography is commitment: what you get out of it in terms of financial rewards is equally proportional to the amount of care and effort you put in. In this, more than most areas of photography, it really is a case of needing to speculate to accumulate.

Name: **DUNCAN MCEWAN**

Duncan is a real amateur success story. A teacher by trade and a photographer by inclination, his landscape, sport and natural history pictures are sold through the Images Colour Library, which he joined seven years ago. He is one of Images' most prolific landscape photographers, and every catalogue produced by the library features many of his pictures.

'Since joining Images I've put together about 3,500 pictures, covering a wide range of subjects. Being an amateur I'm in the fortunate position of not having to earn money from my photography, so I tend to have quite a casual, cavalier approach. While professionals go out looking for specific subjects, I shoot things because I like the light, or the composition. It just so happens that some of the pictures are also saleable.

'There's always an element of luck in stock photography, and I haven't quite fathomed out how it works. The picture that has earned me the most is one that I'd never think of entering into competitions, whereas the pictures I think will sell lie dormant for five years then suddenly appear on a sales invoice. I can't complain though – and sales far outweigh my expectations.

It's the last place I'd expect to be commercial, but tourism and industry has increased in recent years so it has become more important. That could happen anywhere. The thing about stock photography is you needn't always have a breathtaking picture, often it simply needs to illustrate a specific point.

'Rising with the larks doesn't come naturally, but I do it because my bestsellers tend to be early morning shots. Saying that, I've also sold many pictures taken in the middle of the day. I'm not one of those photographers who puts his feet up between ten and four, I just shoot continuously.

'Concentrating on a local area is something I'd advise any photographer to do. Not only does it mean that you build up a reputation for specializing in a particular place, but it also keeps travel costs to a minimum, you become attuned to the environment, and you're able to cover all aspects of that area.

'I've even sold a lot of pictures of my home town.

'I manage to make a reasonable income by taking the pictures I would take anyway. Professionals have to go out and take saleable pictures every day, whereas I don't. I suppose you could say I've got the best of both worlds.'

These three pictures have all made regular sales for Duncan McEwan, and earned him handsome reproduction fees. Duncan has also maximized his sales by diversifying into different subject areas such as close-ups and sports photography, as well as landscapes. Although only a part-time stock photographer, he is one of the Images Colour Library's most prolific and successful contributors, far out-selling many of the established professionals, due to the high standard of his work.

Name: RICHARD ROBINSON

Twelve years ago, Richard formed the Images Colour Library using the work of landscape photographer Derry Brabbs and a small band of other contributors. Today it ranks as one of the UK's top picture libraries, with offices in Northern England and central London. A couple of years ago, Images also took on the Landscape Only library stock, and their 15th catalogue has just been printed.

'Today, Images has over 80 contributors with anything up to 10,000 pictures each on file, and their stock is syndicated worldwide by a network of 22 overseas agents who hold duplicated slides and copies of our catalogues. UK business comes mainly from design, PR and advertising agencies, but Images stock is also used in books, magazines, calendars, posters and postcards.

'Stock photography is now big business, and over the last two years we've made a concerted effort to join the big libraries, like Tony Stone, by producing more catalogues, opening additional offices and expanding our portfolio.

'When I started I ran the operation alone, but now there's a team of 20 people and we've just bought bigger premises in Leeds.

'I think the recession has made stock photography more popular among picture buyers. At one stage about half my clients went out of business and I had a lot of bad debt to handle, but at the same time, more advertising agencies and publishers started using stock pictures rather than commissioning photographers because it is much cheaper.

'What most photographers don't realise is the amount of money it takes to run a library and market their stock. I had 100,000 copies of our latest catalogue printed and distributed around the world, which cost a small fortune. Many libraries save money by charging each photographer whose work

appears in the catalogue, but I don't. Instead, I sell copies to overseas agents and help cover costs that way. Doing this also means I can have a much bigger print run of catalogues, and that brings the unit cost down. It's an expensive game, but it works. Around 70 per cent of all picture sales come from catalogues, so libraries who don't produce them just can't keep up with the competition. Buyers don't want to spend ages looking through files any more. They want to flick through a catalogue then order their images over the telephone.

'We started producing catalogues about seven years ago, so we can now afford bigger ones. Libraries just starting out will find that really tough. Our photographers have also found this to be very beneficial. I'd say catalogue images sell ten times more than file shots, and some contributors make a lot of money.

'I'm always keen to see the work of new photographers, but it's quality I'm interested in, not quantity. I don't like the idea of representing 600 photographers – we have about 40 major contributors, and that's fine. At the moment I'm approached by about one new contributor per day and take on about one a month.

'It's the same with the pictures. I'd rather someone came along with 20 brilliant shots that will sell, rather than thousands of mediocre ones that won't. It costs a lot of time and money to get a new photographer into our system, so unless their pictures will sell, there's no point.

'Standards in stock photography have also increased dramatically in recent years. The days when photographers cleared out their bottom drawer and left the contents with a library are long gone. I'm only interested in seeing technically perfect images. They must be pin-sharp, perfectly exposed and well composed, otherwise they'll never leave the files.

'Our contributors work on different levels. Some specialize in one subject and have only two or so hundred pictures with us, while a few are full-time

2266 *Murray Irving*

2267 *Murray Irving*

2268 *Melanie Carr/Zephyr*

2265 *Murray Irving*

2269 *Melanie Carr/Zephyr*

2270 *Melanie Carr/Zephyr*

2271 *Melanie Carr/Zephyr*

2272 *Melanie Carr/Zephyr*

Like many successful libraries, Images invests large amounts of money into having top quality colour catalogues of their best photographs produced.

stock photographers with many thousands. Earnings are also relative to the subject. A landscape or travel photographer with 10,000 pictures will earn less than a business and model photographer with the same number of pictures.

With that in mind, there's no point in a travel, landscape or general photographer coming along with 10 shots because they aren't going to earn much, if anything at all. I need to see perhaps 500, with the promise that more will be added on a regular basis over the years so the total builds up to an impressive number. To get a worthwhile return from stock you need to have several thousand pictures on file, so that's a target every contributor should aim for.

'My theory is simple. We want to make a lot of money for the photographers we take on, and are willing to put a lot of effort into representing them. But we can't succeed unless they want to make a lot of money too.'

USEFUL INFORMATION

THE INFORMATION GIVEN in this section is of specific use to freelance photographers both in these respective countries, and those wishing to sell pictures or operate as a photographer overseas.

If you intend submitting work to a picture library in Germany, for example, and you live in the UK, telephone or fax the relevant German association and they will be happy to supply you with a comprehensive list of picture libraries throughout the country. Similarly, if you intend working in an overseas country, the professional organizations there can advise on average rates for professional photography, be it for commissioned work or picture sales.

The professional bodies may also be able to provide details of services that cannot be listed in this book due to the lack of space, such as processing laboratories, studios, equipment hire centres, equipment repair specialists, and other particular services you may require the use of while working abroad.

What you should remember is that while most of the bodies listed may be able to read and speak English, any literature they supply will probably be supplied in the native language.

Note: All telephone numbers and fax numbers must be prefixed by the appropriate International dialling code for the country from which you are calling.

PROFESSIONAL PHOTOGRAPHIC BODIES

UNITED KINGDOM

Association of Model Agents
The Clock House, St Catherine's Mews, Milner Street, London SW3 2PX. Tel: 0171 584 6466

Association of Photographers
9/10 Domingo Street, London EC1 OTA. Tel: 0171 608 1441. Fax: 0171 253 3007.

Bureau of Freelance Photographers (BFP)
Focus House, 497 Green Lanes, London N13 4BP. Tel: 0181 882 3315/6. Fax: 0181 886 5174.

British Association of Picture Libraries and Agencies
13 Woolberry Crescent, London N10 1PJ. Tel: 0181 444 7913. Fax: 0181 883 9215.

British Institute of Professional Photography (BIPP)
Amwell End, Ware, Hertfordshire, SG12 9HN. Tel: 01920 464011. Fax: 01920 487056.

British Photographer's Liason Committee (BPLC)
9-10 Domingo Street, London EC1 OTA. Tel: 0171 608 1441. Fax: 0171 253 3007.

Guild of Wedding Photographers
13 Market Street, Altrincham, Cheshire WA14 1QS. Tel: 0161 926 9367. Fax: 0161 929 1786.

Master Photographers' Association (MPA)

Hallmark House, 2 Beaumont Street, Darlington, Co Durham DL1 5SZ. Tel: 01325 356555. Fax: 01325 357812.

Royal Photographic Society (RPS)

The Octagon, Milsom Street, Bath, Avon BA1 1DN. Tel: 01225 462841. Fax: 01225 448688.

Society of Picture Researchers and Editors

BM Box 259, London WC1N 3XX. Tel: 0171 404 5011 (for Freelance Register). Tel: 0727 833676. Fax: 0171 831 9489.

Society of Wedding and Portrait Photographers

5 Liverpool Road, Ashton Cross, Wigan WN4 OYT. Tel: 01942 728956. Fax: 01942 725448.

EUROPE

Associazione Fotografi Italiani Professionisti (AFIP)

Via Domenichino 19, 20149 Milano, Italy. Tel: 2 48014758. Fax: 2 48014767.

Associacion de Fotografos Professionales y Publicidad de Moda

Juan Hurtado de Mendoza 9/507, 28036 Madrid, Spain. Tel: 1 250 4722. Fax: 1 359 6977.

Associacion Agencias Informativas Espanolas

Centro de Prensa, Claudio Coello 98, 28006 Madrid, Spain. Tel: 1 446 1766. Fax: 1 446 7706.

Beroeps Fotografen Nederland

Largest body for professional photographers in the Netherlands.
Prinses Jullanaplein 14C, 3817 CS Amersfoort, Netherlands. Tel: 33 656 290. Fax: 33 565 283.

Bund Freischaffender Foto-Designer (BFF)

Main German body for freelance photographers.
Postfach 750347 Tuttelinger Strasse 95, 7000 Stuttgart 75, Germany. Tel: 711 47 34 22. Fax: 711 47 52 80.

Bundesverband der Pressebild-Agenturen Bildarchive (BVPA)

German association of picture libraries.
Mommsenstrasse 21, 1000 Berlin 12, Germany. Tel: 30 3 24 99 17. Fax: 30 3 24 70 01.

Federation Francaise des Agences de Presse & d'information Audiovisuelle (FFAPA)

Main French body for professional photographers and agents.
32 Rue de Laborder, 75005 Paris, France. Tel: 1 4293 4257. Fax: 1 4293 4257.

Gruppo Agenzie Distributori e Fotoreporter (GADEF)

Italian association of picture agencies and photo-journalists.
Via Domenichino 19, 20149 Milano, Italy.
Tel: 2 48013630. Fax: 2 48014767.

Association of Norwegian Picture Libraries (NBBF)

c/o Advocatene Haavind & Haga, Drammensveien 20 A, PO Box 2338 Solli, 0201 Oslo, Norway.
Tel: 2 2447850. Fax: 2 2444401.

Syndicat des Agences de Presse Photographiques (SAPP)

French body for press photographers and photo-journalists.
6 Rue Gabriel Laumain, 75484 Paris 10, France.
Tel: 1 4264 0404. Fax: 1 4246 1403.

Schweizerische Arbeitsgemienschaft der Bild-Agenturen und Archive

Swiss Association of Picture Libraries.
Postfach 15, 5303 Wurlingen, Switzerland.
Tel: 56 98 12 31. FAX: 56 98 22 49.

World Council of Professional Photographers (WCPP)

Can supply further information on worldwide photographic bodies, groups and associations.
31 Exchequer Street, Dublin 2, Ireland.

UNITED STATES OF AMERICA
American Society of Photographers (ASP)
Box 3191, Spartanburg SC 29304.
Tel: 803 582 3115.

National Press Photographers' Association (NPPA)
Suite 306, 3200 Croasdaile Dr, Durham, NC 27705.
Tel: 800 289 6772.

Photographic Society of America (PSA)
Suite 103, 3000 United Founders Blvd, Oklahoma City, OK 73112. Tel: 405 843 1437.

Picture Agency Council of America (PACA)
PO Box 308, Northfield, MN 55057-0308.
Tel: 800 457 7222.

Professional Photographers of America (PPA)
57 Forsyth Street, NW, Atlanta, GA 30303.
Tel: 708 299 2685.

Wedding Photographer's International (WPI)
PO Box 2003, 1312 Lincoln Blvd, Santa Monica, CA 90406. Tel: 310 451 0090.

FREELANCE MARKET INFORMATION

The following publications offer specific information about picture requirements in various sectors of the publishing industry, and are invaluable for freelance photographers looking for new markets in which to sell their work.

UNITED KINGDOM
The Freelance Photographer's Market Handbook
Bureau of Freelance Photographers, Focus House, 497 Green Lanes, London N13 4BP. Tel: 0181 882 3315/6. Fax: 0181 886 5174.

Annual publication providing picture requirements for magazines, picture libraries, postcard, calendar and book publishers and national newspapers in the UK.

Writers' & Artists' Yearbook
A&C Black Publishers Ltd, 38 Bedford Row, London WC1R 4JH. Tel: 0171 242 0946. Fax: 0171 254 5325. Annual guide listing magazines in UK and overseas, postcard, greetings card and calendar publishers, picture libraries, and other markets of interest to the freelance writer/photographer.

Willings Press Guide
Reed Information Services, Windsor Court, East Grinstead House, East Grinstead, West Sussex RH19 1XA. Tel: 01342 335889. Fax: 01342 335977. Annual guide listing all magazines in print in the UK, as well as other useful publishing information.

BJP Market Newsletter
Bureau of Freelance Photographers, Focus House, 497 Green Lanes, London N13 4BP. Tel: 0181 882 3315/6. Fax: 0181 886 5174.
Monthly newsletter listing picture requirements for a variety of markets, and updating reader on changes in publishing world, such as new magazines and book. Supplied free to members of BFP.

Freelance Focus
7 King Edward's Terrace, Brough, North Humberside HU15 1EE. Tel: 01482 666036.
Fortnightly market update providing listing of picture requirements from all areas of the publishing industry, though primarily books and magazines. Ideal for finding new markets. Supplied to subscribers only.

Cash For Your Camera
PO Box 310, Peterborough, Cambs., England, PE3 6EA.
Fortnightly newsletter providing up-to-the-minute picture requirements from book, magazine, calendar and postcard publishers, plus picture libraries, researchers, and advertising agencies. Supplied on subscription only, and co-edited by the author of this book, Lee Frost.

EUROPE

No specific market information regarding picture requirements appears to be available at the time of writing, and none of the freelance bodies in the UK were aware of such publications.

USA

The Stock Workbook

Scott & Daughters Publishing Inc, Suite A, 940 N, Highland Ave, Los Angeles, CA 90038. Tel: 213 856 0008.
Annual directory of picture libraries in the USA.

Photographer's Market

Writer's Digest Books, 1507 Dana Ave, Cincinnati, Ohio 45207. Tel: 513 531 2222.
Annual directory listing the picture requirements of book publishers, magazines, galleries, advertising agencies, record companies, picture libraries and many other markets in the USA, plus advice on how to sell in the USA – over 650 pages.

Greetings Magazine

MacKay Publishing Corp, 309 Fifth Avenue, New York, NY 10016. Tel: 212 679 6677.
Monthly magazines covering opportunities/changes in the greetings card and stationery business.

Photosource International

Pike Lake Farm, 1910 35th Rd, Osceola, WI 54020. Tel: 715 248 3800.
Publishes useful newsletters including PhotoMarket and Photo Bulletin.

PICTURE LIBRARIES

The libraries listed here are just a small sample of the number that exists in each country. For a more comprehensive listing, refer to one of the freelance guidebooks detailed above or contact the association of picture libraries in the relevant country. Also refer to the Shooting Stock section of this book for general advice on how to work with a picture library.

Before sending pictures to any library, phone, fax or write in the first instance to obtain further guidance.

UNITED KINGDOM

Ace Photo Agency

22 Maddox Street, London W1R 9PG.
Tel: 0171 629 0303.
A general library covering all subjects from travel and sport and natural history and people. All formats are accepted from 35mm up, and a minimum submission of 200 pictures is required.

Planet Earth Pictures

4 Harcourt Street, London W1H 1DS.
Tel: 0171 262 4427.
Specialises in natural history: wildlife, landscape, marine, ecology. Accepts all formats, and has no minimum submission – phone for an information booklet.

Bubbles Photo Library

23a Benwell Street, London N7 7BL.
Tel: 0171 609 4547.
Concentrates mainly on children, babies, pregnancy, child birth, parenting, old age, family life. Need to see 100 pictures initially and expect regular top-ups of new work. All formats from 35mm.

Action Images Ltd

74 Willoughby Lane, London N17 OSP.
Tel: 0181 885 3000.
Specialises in sport pictures, covering all events but particularly fond of dramatic shots. 35mm and medium-format are accepted, there's no initial submission, but phone first before sending pics.

Bruce Coleman Ltd

16 Chiltern Business Village, Arundel Road, Uxbridge, Middlesex UB8 2SN.
Tel: 01895 257094.
A well respected natural history library covering worldwide environmental subjects, geography, history, travel, science, marine and much more. Accepts 35mm and requires initial submission of 250 pictures. Phone or write for details.

Travel Photo International
8 Delph Common Road, Aughton, Ormskirk, Lancashire L39 5DW. Tel: 01695 423720. Specialises in world travel and tourism, accepts 35mm but prefers medium-format, and requires 100 pictures initially.

Spectrum Colour Library
41/42 Berners Street, London W1P 4AA.
Tel: 0171 637 1587.
A general library covering travel, scenics, people, natural history. Prefers medium-format, but top quality 35mm okay, requires initial submission of 500 pictures.

The Northern Picture Library
Greenheys Business Centre, 10 Pencroft Way, Manchester M15 6JJ. Tel: 0161 226 2007. General library covering all subjects. No initial submission as quality is preferable to quantity, but prefers 6x7cm or 5x4inch over 35mm.

Images Colour library
15-17 High Court Lane, The Calls, Leeds, Yorkshire, LS2 7EU, England.
Tel: 0113 243 3389.
A general library covering everything from people and health to travel and agriculture. Also has office in central London and worldwide network of agents. No initial submission. 35mm accepted, but medium-format preferred.

Robert Harding Picture Library Ltd
58-59 Great Marlborough Street, London W1V 1DD.
Tel: 0171 287 5414.
A well-established general picture library used mainly for editorial work but now moving into advertising as well. Covers all subjects in all formats from 35mm up and requests a minimum initial submission of 100 colour slides.

EUROPE
All the picture libraries listed in this section are general in terms of their subject requirements. However, it's worth contacting them before submitting material to determine their exact requirements and whether or not they are taking on new contributors.

Superbild GmBH
Glinkastr 28, 10117 Berlin-Mitte, Germany.
Tel: 30 2 29 90 08. Fax: 30 2 29 30 45.
Represented in the UK, France, Holland, Austria, and with other offices in Germany.

ZEFA – Zentrale Farbbild Agentur
Schanzenstr 20, D-4000, Dusseldorf 11, Germany.
Tel: 211 57 40 37. Fax: 211 55 35 56.
Also has offices in the UK (London), France, Italy, Holland, Austria and Switzerland.

Comos
55 Blvd Latour Maubourg, 75007, Paris, France.
Tel: 45 05 44 29. Fax: 47 05 42 05.

Sunset Agence Photographique
6 Rue De Vaucouleurs, 75011 Paris, France,
Tel: 1 47 00 52 32. Fax: 1 40 24 80 34.

The Slide File
79 Merrion Square, Dublin 2, Ireland. Tel: 1 6766850.
Fax: 1 6608332.
Also represented in the UK by Images of London and Leeds.

International Colour Press
Via Alberta de Giussano 15, 20145 Milan, Italy.
Tel: 2 48008493. Fax: 2 48195625.

Overseas Fotographica
Via Moscova 44/1, 20141 Milano, Italy.
Tel: 2 6598509. Fax: 2 6572552.

Stockphotos
Carnonero y Sol 30, 28006 Madrid, Spain.
Tel: 1 564 40 95. Fax: 1 564 43 53.

AGE Fotostock
Buenaventura Munoz 16, 08018 Barcelona, Spain.
Tel: 3 300 25 52. Fax: 3 309 39 77.

Keystone Colour
Grubenstr 45, CH-8045 Zurich, Switzerland.
Tel: 1 462 06 20. Fax: 1 461 64 69.

USA

There are literally hundreds of picture libraries or stock photo agencies in the USA, so we can only touch on a handful in this book. For a full listing, get hold of a copy of *The Freelance Photographer's Market Handbook*, details of which are included in this section.

American Stock Photography

Dept PM, Suite 716, 6255 Sunset Blvd, Hollywood, CA 90028. Tel: 213 469 3900.
General library covering all subjects, currently holds over 2 million images. Accepts 35mm and medium-format.

Frozen Images Inc

Suite 512, 400 First Ave, N Minneapolis MN 55401. Tel: 612 339 3191.
Accepts all subjects for all markets: sports, travel, people, scenics, abstracts, background etc.

Leo De Wys Inc

1170 Broadway, New York, NY 10001. Tel: 212 689 5580. Fax: 212 545 1185.
Travel and foreign destinations plus people worldwide.

Deveney Stock Photo

Suite 306, 755 New York Avenue, Huntington, NY 11743. Tel: 516 673 4477. Fax: 516 673 4440.
Over half a million pictures on file, keen to see more on any subject in any format from 35mm up.

Picture Perfect USA Inc

PO Box 20058, New York, NY 10023. Tel: 212 627 1234. Fax: 212 807 8691.
Subjects: people, industry, travel, scenics, sports, recreation, commerce, lifestyles.

Ro-Ma Stock

3101 West Riverside Drive, Burbank, CA 91505-4741. Tel: 818 842 3777. Fax: 818 566 7380.
General library requiring all subjects in format from 35mm up. 70mm dupes also accepted.

Spectrum Photo

3127 W 12 Mile Road, Berkley, MI 48072. Tel: 313 398 3630. Fax: 313 398 3997.

All subjects, business, industry, food, lifestyles and backgrounds. Format from 35mm up.

The Stock Market

Dept PM, 360 Park Ave South, New York, NY 10010. Tel: 212 684 7878.
Subjects: nature, travel, industry, corporate, people, lifestyles.

Tony Stone Image Inc

1250, 6100 Wiltshire Blvd, Los Angeles, CA 90048. Tel: 213 938 1700.
Has offices in 15 countries worldwide, one of the biggest and best libraries. All subjects, all format, but material must be of highest standard.

Zephyr Picture

339 N Highway 101, Solana Beach, CA 92075-1130. Tel: 619 755 1200. Fax: 619 755 3723.
All subjects from around the world in formats from 35mm up to 10x8inch.

AUSTRALIA

The Photo Library

Level 1, N°7 West Street, North Sydney 2060 NSW. Tel: 02 929 8511.
Accepts all general subjects and sells to all markets. Formats from 35mm up.

CALENDAR/ POSTCARD PUBLISHERS

UNITED KINGDOM

J. Arthur Dixon

Forest Side, Newport, Isle of Wight, PO30 5QW. Tel: 01983 523381.
Publish scenic postcards throughout the UK featuring landscapes, coastal views, inland towns, village scenes, country cottages and more.

J. Salmon

100 London Road, Sevenoaks, Kent, TN13 1BB. Tel: 01732 452381.

Postcards and calendars of all popular UK tourist locations both coastal and inland, plus flowers, cats and dogs, horses, gardens and natural history for calendars and greetings cards.

ETW Dennis & Son
Printing House Square, Melrose Street, Scarborough, Yorkshire YO12 7SH. Tel: 01723 500555.
Publishes calendars and postcards featuring shots of coastal and inland locations, well known tourist destinations and country scenes. Also some scope for animals and flowers.

Jarrold Publishing
Whitefriars, Norwich, Norfolk, NR3 1TR. Tel: 01603 763300.
Accepts picturesque scenes from anywhere in the UK, though preferably of well-known areas, plus animals, pets, flowers and gardens for calendars. Submissions considered between April and August.

Calendar Concepts and Design
33 Albury Avenue, Isleworth, Middlesex, TW7 5HY. Tel: 0181 847 3777.
Hold work on file and act like an agent, selling it to clients for high quality corporate calendars. Only the very best will be accepted. Subjects covered are landscapes in the UK, wildlife, glamour, cats and horses.

Valentines Ltd
PO Box 100, Bath, Avon, BA1 2BA. Tel: 01225 44454.
Require medium or large format shots of outdoors scenes, sport, animals and flowers for greetings cards and calendars.

The Medici Society
34-42 Pentonville Road, London N1 9HG. Tel: 0171 837 7099.
Highly respected publisher of quality greetings cards and calendars. Will consider pictures of flowers, wildlife, pets, snowy landscapes, ideally on formats larger than 35mm. Send a sample of six pictures initially.

USA
American Greetings
10500 American Road, Cleveland, Ohio 44144.
No information available, but one of three top card publishers in the USA. Write for details of subject requirements.

Art Resource International Ltd
Fields Lane, Brewster NY 10509.
Tel: 914 277 8888. Fax: 914 277 8602.
Buys 500 pictures per year for posters and fine art prints. Will accept all subjects.

Gibsons Greetings Inc
2100 Section Road, Cincinnati, Ohio 45222.
No detail available, but one of biggest card producers in the USA, so write for picture requirements.

Hallmark Cards Inc
2501 McGee, Drop 152, Kansas City, MO 64108.
Reluctant to release phone number or specific details, but are one of the USA's three biggest card publishers, so worth writing to.for further information.

Landmark Calendars
PO Box 6105, 51 Digital Drive, Novato, CA 94948-6105. Tel: 415 883 1600. Fax: 415 883 6725.
Buys over 3,000 pictures per year for use in calendar range. Subjects include scenic, nature, travel, sport, cars, animals, food, people. Submit Nov-Feb each year for selection process.

Arthur A Kaplan Co Inc
460 West 34th Street, New York, NY 10001. Tel: 212 947 8989.
Subjects for posters, cards and fine art prints. Particularly interested in shots with international appeal, all formats from 35mm.

Teldon Calendars
Box 8110, 800-250 High Street, Blaine, WA 98231 2107. Tel: 206 945 1211. Fax: 206 945 0555.
Buys over 1,000 picture annually for corporate calendars. Subjects include world travel, classic cars, golf shots, North American images etc.

INDEX